LEONARDO DA VINCI

Books in the RENAISSANCE LIVES series explore and illustrate the life histories and achievements of significant artists, intellectuals and scientists in the early modern world. They delve into literature, philosophy, the history of art, science and natural history and cover narratives of exploration, statecraft and technology.

Series Editor: François Quiviger

LEONARDO DA VINCI

Self, Art and Nature

FRANÇOIS QUIVIGER

REAKTION BOOKS

Published by Reaktion Books Ltd
Unit 32, Waterside
44–48 Wharf Road
London N1 7UX, UK
www.reaktionbooks.co.uk

First published 2019

Printed and bound in China by 1010 Printing International Ltd

A catalogue record for this book is available from the British Library

ISBN 978 1 78914 070 5

COVER: Leonardo da Vinci, *Lady with an Ermine*, 1489–90, oil on panel.
Muzeum Narodowe/the Princes Czartoryski Museum, Kraków –
photo laboratory Stock National Museum, Kraków.

CONTENTS

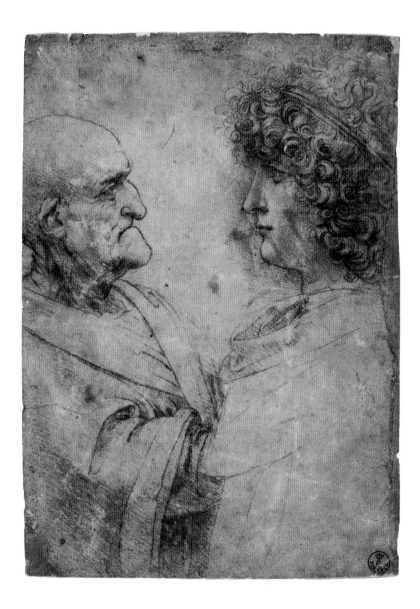

Introduction

hough Leonardo da Vinci might be the greatest Western painter of all time, and the maker of the most expensive painting ever sold, painting occupied only a small fraction of his time. In a life spanning 67 years he produced only about twenty paintings; had he not painted, he would have been remembered as no more than an interesting and original historical character. Although popular culture has credited Leonardo with many inventions and characterized him as a universal genius, in art as in other fields he merely followed, improved and developed pre-existing traditions. His knowledge was far from universal, either. He received only a basic vernacular education, read Latin with difficulty and never attended university. Yet his life and work demonstrate that universality can be achieved outside the confines of institutional knowledge, through the possibilities granted by the visual arts.

Leonardo was born in April 1452 the illegitimate son of a young notary and a peasant's daughter. He spent the first years of his life in the countryside and would have remained merely a clever farm boy had his father not decided to take him to Florence and place him as an apprentice in the workshop of the most famous artists of the time. Thus it could be said that

1 Leonardo da Vinci, *An Old Man and a Youth in Facing Profile*, c. 1495–1500, red chalk on paper.

he had two masters, Nature and Art; and it was thanks to these that he produced images that changed the course of art history and gave new shape to the Western imagination.

This short biography examines the processes through which Leonardo used his understanding of art, nature and society to shape his pictorial work as well as his own persona, which, seen from the distance granted by history, is as remarkable as his artistic legacy.

A typology proposed by John Jeffries Martin advances three types of self within the Renaissance context: the 'communal' or 'civic' self, the 'prudential' or 'performative' self and the 'porous' self.[1] The first relates to social groups, family and lineage. Leonardo's civic self encompasses the whole of Renaissance society. His family and lineage connect him to peasants and farm workers through his mother, to the Florentine bourgeoisie through his father, and the artist and artisan class through his master Andrea del Verrocchio. By the time he reaches his thirties he mingles with and becomes part of European high society as part of the entourages of kings and rulers. In other words, Leonardo's civic self is a fresco of Renaissance society, from the peasant to the king.

The prudential self handles relations between the inside and the outside worlds. Within this category we might highlight Leonardo's ability to adapt to varied situations: to morph into a musician, architect, painter, sculptor, costume designer, military and hydraulic engineer, cartographer and philosopher, as well as the perfect courtier ready to entertain, dance, seduce, convince and amuse or serve his lord with exemplary efficiency. Unlike other artisan- or artist-writers, such as the Frenchman Bernard Palissy or the Florentine Benvenuto

Cellini, he was not particularly boastful. But, like them, he privileged experience over theory. The correspondence Leonardo left merely suggests that he adopted what he deemed the most suitable stance with which to address a given interlocutor – an ability enabled by his deep and panoramic knowledge of human beings.

The porous self primarily expresses the difficulty modern-day scholars experience when trying to delimit the self as an independent thinking entity. The Renaissance porous self emerges from accounts of spirits, possessions and planetary influences as well as the broad assumption, characteristic of early modern science and philosophy, that humans and the world are composed of the same elements, on the balance of which health depends. The porous self is thus best understood through Leonardo's immersive relationship with nature. For him the rational and sensitive faculties of the soul delimit the thinking self but are also part of nature. The self, and indeed humans, are in continuity with the world rather than distinct from it. This porous sense of being connects to Leonardo's sense of nature as a living organism comparable to the human body, as well as to his painting method, the *sfumato*, which gently connects things by blurring their outlines.

A great deal of what we know about Leonardo comes from the *Life* written by Giorgio Vasari (1550, 1568). The author reports that one day the young Leonardo collected snakes, reptiles and frogs to use in painting a shield with a Medusa's head. He was so absorbed by his work that he remained indifferent to the stench of his decaying models.[2] The tale sounds odd, as painting required the tools and support of a workshop – there was no such thing as ready-mixed paint in tubes until

the mid-eighteenth century. Yet the story rings true in regard to Leonardo's obsessive thirst for observing nature through graphic and pictorial means. It sounds plausible too in terms of his studies in anatomy, which would have demanded olfactive indifference to the rising stench of bodily decay. And it also convinces in terms of the research-obsessed personality we know the artist to have been – an understanding that comes out of the writings he left behind, a fifth of which are extant.

Although popular culture casts Leonardo as a Renaissance man, he was in many ways at odds with his time. With only rudimentary knowledge of Latin, he had difficult and limited access to scientific and philosophical literature and displayed no interest in disciplines such as law, astrology or theology. The books he acquired throughout his life do not form a reference library but confirm his need to find out about specific things at different times of his life.[3] Unusually for his time, he was vegetarian, writing with apparent distaste of the idea of turning one's stomach into 'an animal cemetery'.[4] He expressed very little interest in religion, sex or politics. His delight in personal independence and his lifelong bachelorhood are also at odds with the family-oriented ideals of Renaissance Italy. As an unmarried mature man surrounded by younger men he might have been suspected of practising sodomy.[5] Yet, apart from a lawsuit going back to his teenage years – from which he was cleared – Leonardo left hardly any trace of his erotic inclinations and energies.

He lived a great part of his life in palaces serving masters who were sometimes foes, but he was never suspected a traitor and, unlike Michelangelo, never seems to have worried about

his political views. He navigated the tormented sea of Renaissance politics by offering his highly sought-after services, as an artist and military engineer, to the most powerful men of his time. As a Florentine born in the 1450s, he came under the patronage of the Medici, the rulers of fifteenth-century Florence. They sent him to Milan, where he served the ruling Sforza family for eighteen years. In 1499 the French expelled the Sforza and Leonardo began working for the new Gallic masters of Milan, of whom he had actively sought the patronage. Back in Florence he served the short-lived Republican government (1496–1512), which had just expelled the Medici, and spent a year at the service of Cesare Borgia, the flamboyant Duke of Valentinois and son of Pope Alexander VI. Later, when the Medici returned to Florence, Leonardo served them again, joining the suite of Giuliano de' Medici until 1516. By then, Medici patronage had dried up – in spite of the election of a Medici pope, Leo X – and Leonardo left Rome to take up an appointment, and a princely pension, from the French king Francis I.

Although by the last decades of his life his reputation had suffered considerably, Leonardo seems to have succeeded in securing uninterrupted aristocratic patronage, and he died peacefully in a castle given to him by a French king. It can be said of Leonardo that he began as a peasant, grew up as an artist, matured as a perfect courtier and left behind him the image of a Renaissance man. The following pages examine the history of this transformation.

There is no such thing as a definitive book; there are only introductions, and the rest of the path is for the reader to

tread. In the case of Leonardo the path has been smoothed by recent technological developments. The early twentieth-century editions of most of his literary remnants are freely available online. So too are his manuscripts and his paintings and drawings, which can for the most part be examined as high-resolution images, as well as most sources and documents surrounding his life. As one of the most famous men of history he has been scrutinized by generations of scholars, who have examined his multiple activities and written material, ranging from official contracts to shopping lists.[6] This book is no more than an introduction to the historical figure of Leonardo and the relationship he developed with the world through the art of painting.

The Early Florentine Years: Education and Formation

eonardo da Vinci was born on 15 April 1452 the illegitimate son of a local notary, Ser Piero da Vinci, and Caterina, the otherwise unknown daughter of a tenant farmer. Until his early teenage years Leonardo lived at the farm of his mother and grandparents. This bucolic childhood in the Tuscan hills was his first contact with the world and undoubtedly had some bearing on his relation to nature. It could be said that nature was Leonardo's first teacher and that he spent his life understanding and emulating nature with the culture and the means of his time. After the death of his maternal grandparents, his father, who had remarried, took him to Florence, where he had established a successful notarial practice at the service of the Medici. Leonardo's status as an illegitimate child barred him from following in the footsteps of his father in the legal profession. Yet his father seems to have been particularly supportive of his son's endeavours and it was almost certainly thanks to these family connections with the Medici that Leonardo entered the workshop of Andrea del Verrocchio (1435–1488), certainly the most important artist of his time.[1]

Born into a family of brickmakers, Verrocchio (meaning 'true eye') began his career as an apprentice goldsmith,

eventually expanding his skills and prosperous business into painting, sculpture, architecture and engineering. He rose to fame from the 1460s onwards when he became the favourite artist of the Medici. In the world of art history Verrocchio binds the Florentine founders of early fifteenth-century Renaissance art (Masaccio, Lorenzo Ghiberti and Donatello) to the masters of the High Renaissance, Michelangelo and Raphael, through his pupils Leonardo, Botticelli and Lorenzo di Credi.

Verrocchio's workshop produced paintings and sculptures in marble and bronze, including portraits and religious images, as well as bells, doors, candelabra and tombs, with considerable ornamentation. His main works include the tomb slab of Cosimo de' Medici and the tomb of Giovanni and Piero de' Medici, at the church of San Lorenzo (1467; 1472); Florentine landmarks like the *Incredulity of St Thomas* at Orsanmichele church (begun around 1467); and the equestrian monument of Bartolomeo Colleoni in Venice, which he planned from the 1480s.[2] From Verrocchio's decorative work Leonardo learnt to draw and use plants, flowers, berries and leaves as ornamental elements; from group sculptures such as the *St Thomas* at Orsanmichele he approached the art of depicting figures in interaction; while the Colleoni statue set a standard that he tried – but failed – to outdo when he worked on the Sforza horse in Milan during the 1480s and early 1490s.

Minerals are a recurring theme in Leonardo's painting. They already feature as mountains in his early Madonnas and take centre stage in the grottoes and rocky ditches of the two versions of the *Virgin of the Rocks* (see illus. 27, 28). From his apprenticeship with Verrocchio, Leonardo's knowledge of

minerals extended to their multiple properties as malleable media of painting as well as of bronze and marble sculpture. He knew pigments and their various preparations and was one of the first Italian artists to experiment, not always successfully, with the medium of oil, recently imported from Flanders.

Vasari described Verrocchio as an outstanding sculptor and a second-rate painter who abandoned painting when discouraged by the talent of the young Leonardo. Yet, more than a sculptor, Verrocchio was a metalworker, equally outstanding at modelling and casting, producing ornamental work and standing figures. With the art of casting, which Leonardo learnt from Verrocchio, came not only the knowledge of metals and alloys and their acoustic qualities but an awareness of the properties of fire and smoke, which set some of the foundations of Leonardo's work as a military engineer and inventor of war machines.

Through the art of casting, Leonardo also learnt methods of taking and transferring the imprints of real things, such as drapery, leaves, flowers, birds, insects and even humans. At the time Florence was a renowned centre of wax sculpture, producing what we would today call hyperrealist portraits of individuals from casts.[3] The direct casting of real objects was also part of the Florentine sculptors' arsenal of techniques.[4] Imprints of leaves feature in Lorenzo Ghiberti's bronze doors for the Florence Baptistery, while Donatello had no hesitation in using real items of clothing to drape his *Judith and Holofernes* (Florence, Palazzo Vecchio, 1457–64). In spite of its apparently 'objective' character, casting also involved shaping the items to be cast with a certain aesthetic ideal in mind. As we shall see, this aspect of the art of casting carried through in particular

into Leonardo's approach to nature in painting, which is best characterized as an idealism disguised as naturalism.

A copper globe, 2.3 m (7½ ft) in diameter and weighing about 2 tons, to be erected and secured on the roof of the cupola of Florence Cathedral, is probably one of the most interesting commissions Verrocchio was working on at the time of Leonardo's apprenticeship. He produced the golden globe through hammering, soldering and gilding eight pieces of copper which he personally selected in the Veneto.[5] The machinery devised to pull up and successfully affix the globe to the top of the cathedral dome on 27 May 1471 is just one example of the devices used by sculptors to handle, move and install heavy objects. From these experiences Leonardo developed an understanding of machines and machinery as a vocabulary made of elements such as wheels, sprockets, levers and chain drives, that could be applied to multiple purposes, from the moving of heavy objects to devising war machines, revolving theatrical scenes and even automatons.

As the Medicis' favourite artist, Verrocchio contributed to their festive culture, which was among the most refined of its time. Celebrations of baptisms, weddings, state visits and triumphal entries included tournaments, banquets and theatrical performances. In 1471, for instance, Verrocchio was in charge of the decoration of the Palazzo Medici in preparation for the visit in March of Galeazzo Maria Sforza, the ruler of Milan, and he also designed standards and banners for jousts and tournaments.[6] Renaissance festive culture was a space of experimentation and collaboration between artists and intellectuals. Verrocchio's involvement provided a foundation for Leonardo, who would become a master in this domain.

TRAINING

Leonardo's training began with drawing the human body. Apprentices first learned to draw body parts – the eyes, nose, mouth, ears, hands and feet – before moving on to the entire body through a basic study of human anatomy in terms of bones, muscles and skin. Drawing from life and copying from antique art and modern masters was the next stage through which the apprentice would turn his newly acquired skills and visual vocabulary into a personal style. Renaissance art and art education focus on the human figure. Already in 1436 the treatise *Della pittura* (On Painting, originally composed in Latin as *De pictura*) by the humanist architect Leon Battista Alberti expounded the standard method of construction of the figure; this was still taught in nineteenth-century art academies. This method consists in drawing a figure while thinking in terms of bone, muscle, flesh and clothing, mostly drapery.[7] Drapery is considered the final layer of the human figure: it reveals the body and amplifies its emotion by means of light and shadow, folds and colour. Draping a figure was therefore considered the ultimate expression of the mastery of drawing shadows and lights. In real life, cloth covers and protects the human body; in painting it is a means of representing and echoing the movement of the body and soul it envelops. Draperies are like the reverb effect of the human figure and of the person's thoughts and emotions. As part of their training, apprentices would draw draperies from fabrics dipped in plaster and dried on a mannequin or a clay model. This pedagogical background provides the context to Leonardo's early sketches of drapery, an exercise that would also become

a gateway to his research and speculations on light, shade, contour and volume (illus. 2).

FIRST PAINTINGS

Advanced assistants received minor tasks in paintings, land-scapes and subsidiary parts, which the master would eventually retouch. One of Leonardo's first opportunities came when Verrocchio entrusted him with painting an angel at the left of his *Baptism of Christ* of 1475 (illus. 3). According to Vasari, Verrocchio was so impressed that he eventually decided to abandon painting.[8] Leonardo, who wrote that 'he is a poor disciple who does not excel his master,'[9] must have had a mighty good time showing off the skills he had acquired while studying drapery. He even draped the right foot of the angel (illus. 4). The luminous crystal pearls he disposed along the angel's shoulders, and the contrast between the silky blue and yellow drapery and the black velvet he wears are further signs of Leonardo's exuberant display of a newly mastered language of colours, reflections and textures. A floating ribbon at the back of the angel's head enhances the impression of lightness and anticipates the angel of the *Virgin of the Rocks* (see illus. 28) as much as Leonardo's studies on the movement of water and hair (see illus. 67, 68).

The central figure of Christ splits the composition into two parts, with the lush valley of the Jordan river on the left-hand side and the dry desert on the right. There might be theological reasons guiding this arrangement, but Vasari singled out Verrocchio's *Baptism* because it embodied what he and his contemporaries perceived as a striking contrast between

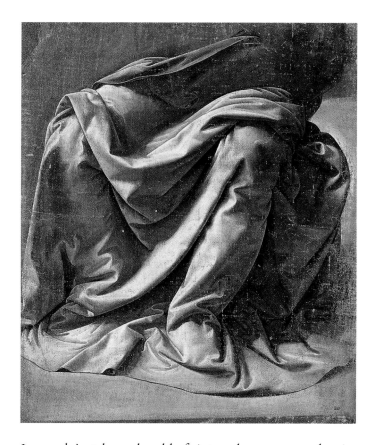

Leonardo's style – a herald of sixteenth-century modernity – and Verrocchio's manner, which was emblematic of the fifteenth century.[10] In this respect Leonardo's first paintings are conventional in terms of iconography but display signs of independence from the approach of his master.

The *Benois Madonna* (*c.* 1478–80) is the first demonstration of Leonardo's pictorial independence (illus. 5). It departs from the format of the Verrocchio workshop style in lighting, corporeality and expression. Such small devotional images

2 Leonardo da Vinci, *Drapery for a Seated Figure*, *c.* 1478, brush and grey tempera on *tela di lino* (linen canvas).

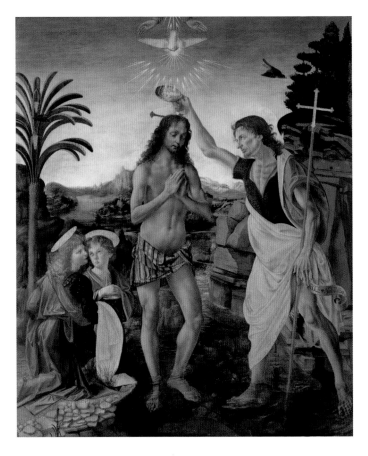

(49.5 × 33 cm/19½ × 13 in.) served to sustain prayer and meditation, bringing the imagination of the Virgin and Child to a familiar domestic interior. It is, however, a strange and unusual work, featuring a disproportionately large baby on the knees of a laughing Madonna. Indeed the baby's head is larger than that of his mother. He holds a cruciform flower, symbolic of the forthcoming Passion. The theme is common but the figure of the Virgin is quite unique. The slight puffiness of her

3 Andrea del Verrocchio, with contributions by Leonardo da Vinci, *The Baptism of Christ*, 1475, oil on panel.

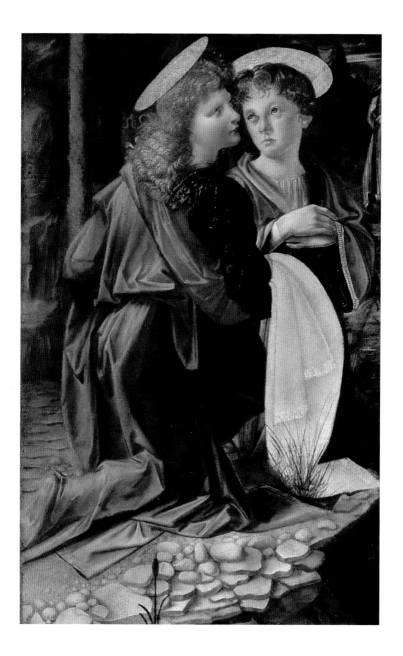

4 Andrea del Verrocchio, with contributions by Leonardo da Vinci,
The Baptism of Christ (detail of the two angels).

chin and neck gives her a physical presence that distinguishes her from the stiffer and dryer Madonnas of Verrocchio. She is laughing: Leonardo has depicted her mouth open and has even traced her teeth, an extremely rare feature in the visual tradition; other than in the grotesque genre and in the iconography of the mocking of Christ, people are very seldom represented laughing in medieval and Renaissance art. Here the format, a small devotional picture for a domestic interior, gave plenty of space to Leonardo to experiment with expression. The *Benois Madonna* is also the first instance of Leonardo's experimentations with *chiaroscuro* and *sfumato* techniques. By juxtaposing light areas against dark ones Leonardo could increase the impression of relief created by his figures, but to avoid making them look like cut-outs, he began to blur their outlines softly.

The *Madonna of the Carnation* (*c.* 1478–80) is one of the most conservative and at the same time most experimental of Leonardo's early works: conservative in terms of iconography, experimental in terms of the use of oil paint (illus. 6). The facial features of the Virgin derive from workshop templates. The composition follows a formula that began to appear in Italy and Flanders in the 1420s whereby a painted parapet is placed in front of a half figure.[11] In portraiture as in religious works, parapets are intermediary devices used to prompt and enhance the illusion of tactile continuity between the viewer and the painted image. Fifteenth-century parapets are the ancestors of the still-life featuring draperies, fruits, flowers, vases, birds, and sometimes even insects and vegetables. In the *Madonna of the Carnation* the child sits at the edge of the picture frame with his right foot coming out of the picture plane.

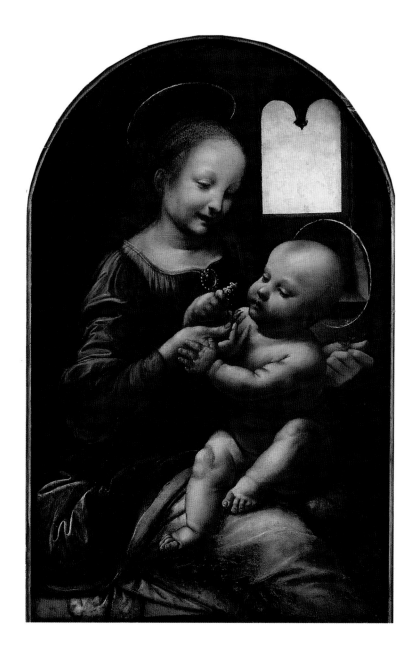

5 Leonardo da Vinci, *Benois Madonna*, c. 1478–80, oil on canvas.

The velvet cushion on which he is seated hints both at the softness of the child's skin and at his volume and weight, this further suggested by the Virgin's right hand, which holds and feels the folds of his flesh.

Comparing the flat, minimal drapery on the parapet of the *Benois Madonna* with the rich display of the *Madonna of the*

6 Leonardo da Vinci, *Madonna of the Carnation*, 1478–80, oil on panel.

Carnation gives a measure of Leonardo's rapid progress in the mastery of the fold. In the *Madonna of the Carnation* the Virgin is still depicted in a very frontal position, in contrast to Leonardo's later tendency to twist his figures and orient their limbs at different angles to the picture plane. Imagining the Christ Child's infantile and impulsive grabbing of flowers or birds as allusive of his future death on the Cross is a particularly common theme of late medieval and Renaissance Madonna and Child imagery. Here the carnation which the child contemplates and attempts to touch symbolizes the Passion, as does the cruciform flower he holds in the *Benoís Madonna*. These representations of impulsions are the earliest examples of a theme that will recur in Leonardo's later works.

These early Madonnas also testify to Leonardo's first experimentations with the medium of oil. The wrinkling on the surface of the painting, particularly visible in the *Madonna of the Carnation*, is a consequence of an excess of oil in the colour preparation. The top layer, exposed to air, dries faster and compresses the oil underneath into wrinkles, as can also be observed in the portrait of *Ginevra de' Benci* (c. 1474–8).[12] Leonardo knew some examples of Flemish painting through his acquaintance with the Medici collections. Details like the transparent vase with flowers in the *Madonna of the Carnation* and the gems and jewels of the Virgin in both paintings, or those of the angels of the *Baptism of Christ*, confirm Leonardo's early engagement with and adaptation of the naturalism of Flemish painting.

Flemish artists like the Van Eyck brothers delighted not only in painting the reflective surfaces of metal, glass, silk and skin, but also in depicting flowers and herbs, which they

arranged as soft and scented meadows for the delicate feet of their standing Madonnas. They were also pioneers in the depiction of landscape. The flowered lawn in the Uffizi *Annunciation* (c. 1472–5) (illus. 7) confirms that Leonardo had by then already integrated such elements of Flemish art, to which he had access in the Medici collections, into his own Florentine visual vocabulary. Verrocchio's ornamental style, based on classical models, is meanwhile recognizable in the lectern

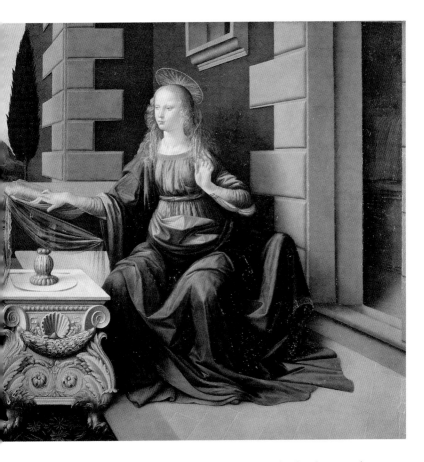

placed in front of the Virgin. The trees in the background are a pretext for a study in botany as much as a demonstration of the variety of trees produced by nature. The bluish landscape as well as the linear perspective, emphatically accentuated by the building on the right-hand side, are the first examples of Leonardo's early approach to the representation of depth.

7 Leonardo da Vinci, *Annunciation*, *c.* 1472, oil on poplar.

ACCESS TO POWER

Thus after spending his childhood in the exquisite Tuscan Hills near Vinci, Leonardo learned the art of transforming nature into images. Through his apprenticeship and stay in Florence he also gained access to the upper layers of Florentine society, as both Verrocchio and Ser Piero, his father, were serving the Medici. The Medici, a political dynasty who also owned the wealthiest bank in Europe, had ruled Florence since 1434, when Cosimo de' Medici (1389–1464) took control of the Republican government. He was succeeded by his son Piero (1416–1469), who in turn was followed by his son Lorenzo (1449–1492) (illus. 8).

Renaissance Italy was not a country but rather a mosaic of competing city-states ruled by local dynasties. At the time of Leonardo's birth the Medici ruled Florence, the Aragon of Spain held Naples, in the north Venice was in the hands of its rich merchant families, the Malatesta governed Rimini, the Este ruled Ferrara, the Gonzaga were the masters of Mantua, the house of Montefeltro ruled Urbino and the Sforza controlled Milan. Florence and Milan in particular were allied. On 26 December 1476, following the assassination of Galeazzo Maria Sforza (1444–1476), the regency of his seven-year-old son Gian Galeazzo (1469–1494) fell into the hands of his widow, Bona of Savoy (1449–1503), and his chancellor, Cicco Simonetta (1410–1480) and from 1481 in the hands of Ludovico Sforza who became the de facto ruler of Milan. This fragile situation had weakened Florence's allies and inspired a plot to overthrow the Medici known as the Pazzi conspiracy.[13] On 26 April 1478, Easter

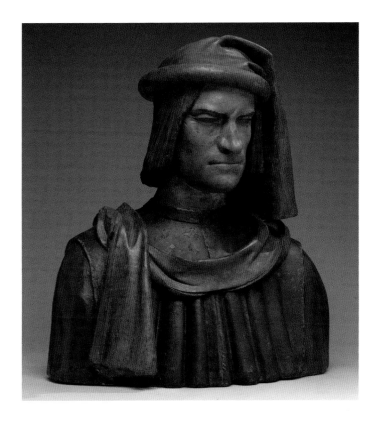

Sunday, henchmen stabbed Lorenzo de' Medici and his brother Giuliano as they were attending Mass in Florence Cathedral. Giuliano died but Lorenzo managed to escape.

The conspirators expected to ignite an uprising against the Medici, with the support of the troops of the Duke of Urbino ready to march into Florence. The half-failed assassination prompted, on the contrary, further popular support for the Medici and strengthened their hold on Florence. In the immediate aftermath about eighty people involved in the plot were caught, beaten and executed. One of the last to be

8 Florentine, 15th or 16th century, probably after a model by Andrea del Verrocchio and Orsino Benintendi, *Lorenzo de' Medici*, 1478–1521, bust painted terracotta.

found was the merchant Bernardo Bandini Baroncelli, who had escaped to Constantinople. Thanks to the cordial links between the Medici bank and the Ottoman authorities, he was captured and escorted back to Florence, where he was hanged in oriental costume on 29 December 1479. We do not know whether Leonardo witnessed the hanging, but he did represent the hanged assassin whose body had been left to decay in public view (illus. 9). On his drawing Leonardo, using the rope as a margin, detailed the colours of Baroncelli's garments. These notes, sometimes characterized as evidence of a sense of detachment, may conversely have been a means of preserving the powerful memory of those intense events through lines and colour notations.

In spite of popular support the Medici were weakened, and it was only thanks to his political wisdom and diplomatic skills that Lorenzo managed to remain in power. Lorenzo died a natural death in 1492. It did not take long for his successor, Piero, to lose power. In 1494 the Medici were expelled from Florence, to return only in 1512 when Giovanni de' Medici recaptured the city.

The Medici were not only a powerful dynasty that would rule and dominate Florence until the eighteenth century, but they also became particularly famous for their patronage of the arts. Cosimo the Elder (1389–1464) initiated this trend through commissions of important architectural and sculptural works to Filippo Brunelleschi, Donatello and Lorenzo Ghiberti and through his support of letters and philosophy. He set up Florence's first public library in 1444, acquired important collections of Greek manuscripts and entrusted Marsilio Ficino and his circle with the Latin translation of

9 Leonardo da Vinci, *Sketch of Bernardo Baroncelli*, 1479, ink on paper.

beretti no di rame
farsetto di raso nero
cioppa nera foderata
giubba turchino foderata
dgholo dgholpe
ardollaro dollacridbba
soppannato dballnto appitti
lato nero crrosso
bernardo di bartholno
baroncighi

chalzenere

Plato's complete works (only his *Meno*, *Phaedo*, *Parmenides* and *Timaeus* were circulating in the West during the Middle Ages).

By the time of Leonardo's birth in 1452, Florence was a bustling, avant-garde European capital of arts and letters. Ficino's circle was hailed as a revival of the Academy of Plato, the great philosophical school founded in ancient Athens around 387 BC. Lorenzo took over government the same year Leonardo moved from Vinci to Florence. He continued and expanded the patronage tradition of his predecessors and promptly became an example of magnificence and wise government consulted and emulated by other rulers of the Italian peninsula. Lorenzo lived in wealth, surrounded by a remarkable collection that ranged from gems, cameos and exotica to antique and modern sculptures as well as medieval and contemporary paintings, mostly Tuscan and Flemish. The collection that decorated his palace – including his bedroom – and accompanied his daily life spanned the entire history of Tuscan art.[14]

The Medici and their artists knew each other from the cradle to the grave. Their relationships were complex and multilayered and are best understood in terms of extension: the arts were an extension of the political persona of the Medici. Art provided the Medici with a means to fashion, display and extend themselves into the world. Indeed, until well into the eighteenth century there was no such thing as 'titles' for works of art, there were only subjects. Artists, including Leonardo, always worked on commission. They can therefore be considered individual authors only insofar as they produced works extending the will, aspirations and individuality of their patrons.

Lorenzo's relationship with the arts also echoes an ideal of aristocratic education already stated in ancient philosophy and applied in humanistic education: the mastery of drawing as a tool to understand the world, draw fortifications and war machines and make sound judgements in matters of art. These views had a considerable impact on Leonardo's use of the visual arts as a means to acquire and represent knowledge. They provide the foundation of the new Renaissance profession of court artist in which Leonardo was soon to flourish.

The Medici used art for domestic and public spaces but also for politics and diplomacy. Lorenzo was always kept informed about the most promising new apprentices – and this is undoubtedly how Leonardo came to his attention. Lorenzo seems also to have further educated promising young artists thanks to his famous sculpture garden, of which two habitués, Leonardo and Michelangelo, would eventually come to dominate the art world of their generation. Until recently, many scholars have doubted the account of Lorenzo's garden given to us by Vasari; its existence has now been established, thus bringing back credibility to Vasari's description:

> This garden was in such wise filled with the best ancient statuary, that the loggia, the walks, and all the apartments were adorned with noble ancient figures of marble, pictures, and other suchlike things, made by the hands of the best masters who ever lived in Italy or elsewhere. And all these works, in addition to the magnificence and adornment that they conferred on that garden, were as a school or academy for the young painters and sculptors, as well as for all others who

were studying the arts of design, and particularly for
the young nobles.[15]

Lorenzo's collection served to educate promising young
artists who would come to his notice through the network
of the Florentine workshops. There they would continue
developing their individual style through the study of antique
and modern art from Lorenzo's family collection. The Medici
collection, or part thereof, spanned the centuries from
antique to modern and thus conveyed a sense of the history
of art, something which Leonardo would later echo in a
section of his notes where he tells the story of Tuscan art.[16]
Thanks to the Medici banking business outlets in Bruges,
Lorenzo's collections also included Flemish paintings and it
is probably through these that Leonardo first became acquain-
ted with the medium of oil painting.[17] Furthermore, the last
sentence of Vasari's quotation confirms that Lorenzo opened
his garden not only to promising young artists but also to
young members of the nobility.

Thus budding artists could become acquainted with their
future patrons. This seems to have meant a little more for Leo-
nardo: perhaps this early contact with the ruling class further
prompted the thought that the arts could be practised for
the sake of acquiring knowledge rather than income. The view
that knowledge of art and some practice of drawing, along
with music, reading and gymnastics, should be part of aristo-
cratic education comes from Book Eight (Ch. 3) of Aristotle's
Politics.[18] Leonardo, who at an early age was reputed an accom-
plished musician, as well as an athletic horse rider and dancer,
might have begun acquiring and developing these upper-class

skills through his first contacts with Florentine high society. The commission of the portrait of Ginevra de' Benci gave him a first opportunity to serve this aristocratic milieu.

THE FIRST PORTRAIT

Sometime in the second half of the 1470s, either 1475–6 or 1478–80, Leonardo painted his portrait of *Ginevra de' Benci* (illus. 10) for the Venetian ambassador Bernardo Bembo, a politician and humanist very much linked to the entourage of Lorenzo de' Medici, which included intellectuals such as Marsilio Ficino, Cristoforo Landino and Angelo Poliziano. During a stay in Florence he experienced a lofty Platonic infatuation with Ginevra, the daughter of the banker Amerigo Benci, whom he met on the occasion of festivities.[19] This passion inspired among Lorenzo's literary circle several poems in praise of the ambassador and apparently prompted the commission of Ginevra's portrait.[20] It is Leonardo's first known female portrait. He would produce only three more in his lifetime: those of Cecilia Gallerani and Lucrezia Crivelli, and the *Mona Lisa* (see illus. 24, 25, 55). It is an early work; Leonardo has not yet fully mastered the *sfumato* technique. Instead of blurring the outlines he uses the fine lines of Ginevra's hair to soften the contours of her face, as well as his own fingertips.

At the time of its making, this portrait initiated a small revolution in the genre, for it is the first known female portrait to present the sitter in a three-quarter pose. Previously, women were depicted either in profile or facing the viewer, with their bust parallel to the picture plane – as in Flemish painting.

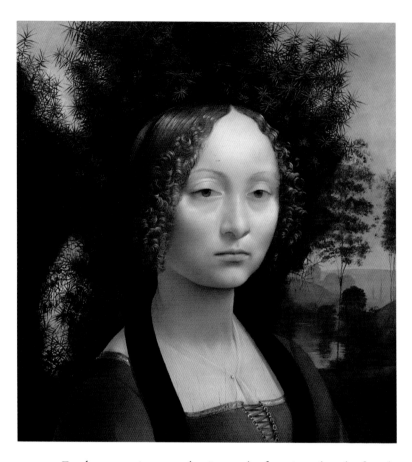

Furthermore, it seems that it was the first time that the female sitter of a portrait was shown looking, so to speak, straight at the viewer.[21] The identity of the sitter is known through documents and confirmed by the juniper bush (*ginepro*) which frames her face like an aura and hints at her name: Ginevra. For a long time scholars assumed that the portrait was either a gift of friendship to the Benci family or a commemoration of Ginevra's wedding, at the age of seventeen. In 1984 Jennifer

10 Leonardo da Vinci, *Ginevra de' Benci*, c. 1474–8, oil on panel.

Fletcher discovered that an image painted on the back of the portrait included the personal emblem of the Venetian ambass-ador Bernardo Bembo: a branch of juniper framed by a laurel and a palm (illus. 11).[22] In the middle, a scroll with the motto *Virtutem forma decorat* (beauty adorns virtue) has been painted over another motto, which reads *Virtus et honor* – virtue and honour. This motto, accompanied by laurel and palm twigs, but no juniper, features in 21 of the 62 manuscripts owned by Bembo.[23] It is therefore in all likelihood his personal emblem, and its presence at the back of Ginevra's portrait implies at the very least a will to connect to her. It has,

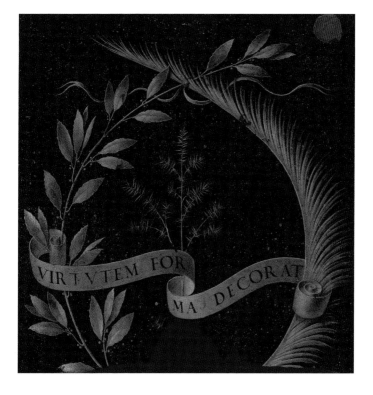

11 Leonardo da Vinci, *Ginevra de' Benci*, reverse, 'Wreath of Laurel, Palm, and Juniper with a Scroll inscribed Virtutem Forma Decorat', *c.* 1474–8, tempera on panel.

however, also been suggested that *Virtus et honor* was initially Ginevra's personal motto, appropriated by Bembo and later changed at the instigation of Ginevra or her family.[24]

This scenario is merely plausible; next to it stands the little we know of Ginevra de' Benci. She received her education from the nuns of the Florentine Benedictine convent of Le Murate, of which her grandfather was the main benefactor. She did not bear any children, suffered a long illness and was buried in the convent dressed in a monastic habit.[25] Her association with Le Murate is suggested in the painting by the black piece of cloth she wears around her neck. It may be a scapular, a kind of scarf worn by nuns as well as tertiaries – people who participated in the life of a convent but lived in the secular world. Apart from this possible allusion there is nothing particularly religious in the painting, and since the lowest part has been lost we do not know what Leonardo placed in Ginevra's hands. A well-known study of hands by Leonardo at Windsor Castle (illus. 12) suggests that she might have held a flower, and there are precedents for this, in particular in Verrocchio's female portrait busts.[26] We also know that she wrote poetry, although only one line of all she wrote remains: 'Chieggio Mercedes e sono alpestro tygre'; 'I beg your forgiveness as I am a mountain tiger.'[27]

Leonardo was skilled enough to paint a laughing Madonna and believed that 'painting considers what the mind may effect by means of the motion of the body.'[28] Thus the melancholic expression he gave to Ginevra is surely intentional, and constitutive of his idea of the young woman he met in person. We shall probably never know the private reasons behind Ginevra's melancholic aspect, yet the contemporary rise of Platonic ideas

about love, which prompted the commission of the portrait, provides a broad historical context.

Platonic love is a spiritual infatuation founded on the assumption that sight and hearing are spiritual senses that perceive some kind of metaphysical beauty and harmony that cannot be apprehended by the 'lower' senses of taste and touch. Thus the perception of harmonious sounds and visible beauty serve as prompts towards ascendance to the contemplation of divine beauty.[29] Platonic love became fashionable from the late fifteenth century onwards through Marsilio Ficino's vernacular commentary on Plato's *Symposium* known as *El libro dell'amore* (1484). Platonic ideas were taken up in Renaissance love poetry, notably in interpretations and imitations of the poetry of Petrarch, whose vernacular *Il Canzoniere*, literally his 'Song Book', in particular was held up as a literary model and an example of ideal behaviour.[30]

Platonic love, in its Renaissance incarnation, is also a matter of the male gaze and the desirable female body. The beauty of the body may reflect that of the soul. Platonism might have brought more deference to women, but to be a step on a ladder – albeit a mystical ladder leading to the divine – is to be a means to an end, rather than an equal. Thus twentieth-century feminist critics have observed that the expansion of Platonism in matters of love contributed to the objectification of women.[31] The shift from medieval courtly love to Platonic love can be envisaged as a transition from power-play to idealization. While in courtly love women and men were envisaged as interacting, in Renaissance Platonic love women are mere objects of male active idealization and passive bearers of a beauty allegedly reflective of the divine.

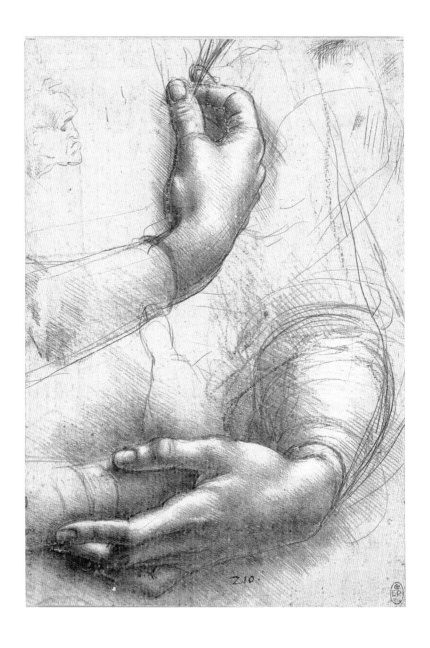

12 Leonardo da Vinci, *Study of Hands*, c. 1474–8, metalpoint on paper.

The Renaissance might have produced Giovanni Pico della Mirandola's *De hominis dignitate* (Discourse on the Dignity of Man, published in 1496), but it was not a particularly good time to be a woman.[32] From the late Middle Ages onwards women's financial conditions worsened and their access to education decreased. Women were considered inferior to men by philosophical and medical authorities such as Aristotle, Galen and their commentators. Social constraints – a youth of seclusion followed by a domestic life as the mother of many children, frequently ending with death in childbirth – considerably limited women's availability to contribute to the arts and sciences of their time. Renaissance society produced very few women writers, and even fewer women painters. Religion was one of the rare fields that offered women space and structure to develop.

In Leonardo's portrait Ginevra is not entirely passive as she looks at the viewer, and if we are to follow Ficino and the long tradition from which he inherited, one falls in love not only by means of one's own sight but also through the gaze of the beloved. Yet Ginevra's expression points to two different mental and emotional spaces: the Platonic gaze, appetite and imagination of the infatuated man who commissioned the picture, and the less than ideal social conditions of Renaissance women. If art reflects its time, then this melancholic portrait would indeed convey that the period was not a good one in which to be a woman.

Be that as it may, Leonardo certainly pleased his patrons. Towards the end of his life Leonardo wrote: 'The Medici created and destroyed me.'[33] The 1470s were the moment of his creation. Spotted by Lorenzo and his circle thanks to his early

Madonnas, the Uffizi *Annunciation*, the unfinished *Adoration of the Magi* of 1481 and the portrait of *Ginevra de' Benci*, Leonardo was now reputed a capable and up-and-coming young artist. He could therefore serve as a pawn in Medici politics. Lorenzo was often consulted on matters of art and architecture by other rulers of the city-states of the Italian peninsula and frequently sent Florentine artists and artisans to other allied city-states, Milan and Naples in particular, as part of his diplomatic work, and also with a view to spreading Tuscan art and style over the Italian peninsula. This is almost certainly the context in which Lorenzo sent Leonardo to Milan in 1482 to serve the Sforzas.

By this time Leonardo had not only earned a good reputation but he also began developing his own ideas on the nature and practice of painting. He began writing and compiling notes and drafts for a treatise on painting, which was eventually abridged and first published in 1651, more than a century after his death, as the *Trattato della pittura*. Such documents are unique in the history of Renaissance art, for most Renaissance artists did not write about their work and kept the transmission of their knowledge in the oral world of the workshop. Leonardo's notes were initially prompted by the necessity of training assistants, but these texts also show how he perfected his own approach to representation. He used painting as a tool to access other provinces of knowledge to become not only an accomplished artist but also an experimental scientist and, as we shall see, a perfect courtier. These ideas are the subject of the next chapter.

Leonardo on Painting

ainting was Leonardo's core discipline, and it was through its practice that he accessed and questioned the world. His writings on painting are therefore the best point of entry to his world; they mostly originate from the need, as an independent painter, to train assistants, and partly from disputations held for the entertainment of the Milanese court. These texts outline the ideas and methods Leonardo practised and developed over a period of forty years, from the first Madonnas (see illus. 5, 6) to the *St John the Baptist* (see illus. 63). Leonardo principally produced religious images, yet he left some texts that cast him as distinctly anti-clerical and very critical of the worship of images, a stance which affected his approach to spectatorship. Thus, after examining Leonardo's writings on painting from the angles of representation and of the acquisition of a personal style, this chapter concludes with observation on Leonardo's views on religious images and their worship.

WORKSHOP PRACTICE AND EDUCATION

By 1481, as confirmed by the contract for the *Adoration of the Magi*, Leonardo worked in Florence as an independent painter.[1] His first notes on painting date from this period and the following decade, when he settled in Milan. They were later collated, shuffled and abridged in 365 short chapters published in 1651 under the title of *Trattato della pittura* (Treatise on Painting).[2] Between then and the end of the eighteenth century the *Trattato* was translated into French, English, German and Spanish, in a total of twelve editions, and 21 were published in the nineteenth century.[3] As the modern editors have observed, this editorial process which Leonardo's writing underwent presented a version of the artist shaped by seventeenth-century academic ideals.[4]

By the seventeenth century, with the progressive transfer of art education from workshops to academies, Leonardo and Raphael had become models of academism: a theory of painting and art education privileging idealism over naturalism. Although his posterity differs from his historical ideas, Leonardo certainly established, as we shall see, a model of idealism disguised as naturalism.

The main difference between the historical Leonardo and the afterlife of his reputation is that the former was not primarily a painter. His formation as an artist working in multiple mediums had given him the tools to awaken and feed his obsession with the workings of nature. Painting is, however, Leonardo's core discipline – not as an end in itself but rather as a means to investigate the energies, variety and abundance of nature. So many aspects of representation led him to inquire

into real things – and to set painting aside for the purpose of research: rocks and geology, rivers and hydraulic engineering, flowers, trees and botany. It is no wonder that Leonardo produced no more than twenty paintings in his lifetime, and this only with the aid of assistants. Learning to represent linen dipped in plaster led him to question the nature and source of light, while linear perspective propelled a lifetime's questioning on the nature and anatomy of vision. Working alongside Verrocchio in the sculpture side of the workshop, his understanding of the properties of minerals and alloys and the toxic fumes they produce under fire might have been first steps towards his invention of explosive cannonballs. The machinery devised to transport and sometimes lift marbles and bronze sculptures several metres above the ground informed the development of his own machines as well as his sense of the human figure, in terms of distribution and shifting of weight.[5]

Leonardo's notes on painting are an amplification of conventional workshop practice as well as starting points in the questions that would occupy him all his life. They are unusual in two respects: first, the notes not only endeavour to teach a series of processes and techniques, but also to transmit ways to train and shape the self and the imagination so as to prepare the apprentice for the practice of painting. Leonardo's notes are therefore documents that reveal not merely how he made paintings but also how he used the process of producing images to shape his own self. Second, Leonardo's writings on painting are also unusual for their occasional focus on problems related to the depiction of landscapes, as well as of objects in general – a subject of only moderate interest in Renaissance art, which was conventionally focused on the human figure.

Yet Leonardo's attention to nature converges with his use of drawing as a means to explore, analyse and understand the world.

Most Italian Renaissance art treatises intended to introduce painting to an educated public. Leonardo, by contrast, addressed his notes in an informal way to his assistants. His principal purpose, as an independent artist, was to form artist-assistants who could work to his standards.

Although Western art history and the modern art market tend to see and assess the value of paintings in terms of individual hands, Renaissance paintings and sculptures were to a large extent products of collaborative work. This included not only the preparation of surfaces and colours but also interventions on the painted surface itself. One characteristic way in which artists worked consisted in drawing a composition on a cartoon and then pricking and transferring the outlines on to a panel. From there the workshop master, after mapping the main areas of light and shade, would supervise his assistants and intervene to correct one thing or another.[6]

Analysing works such as the *Virgin of the Rocks* or the *Salvator Mundi* is now considered less a matter of discerning Leonardo's hand than of understanding the way in which he used and directed his assistants.[7] Thus there is a strong likelihood that assistants participated in paintings now exclusively attributed to Leonardo's hand. For instance, he obtained chromatic depth and luminosity through multiple fine layers of transparent colours, many of which might have been applied by trusted assistants.

As the years went by, Leonardo's interests in anatomy, mathematics and geology as much as his assignments in

engineering and architecture, theatre design and courtly entertainments took him away from painting, much of which he entrusted to at least two assistants, Salaì (Gian Giacomo Caprotti da Oreno, 1480–before 1524) and Francesco Melzi (*c.* 1491–1568/70), both hired in Milan and who remained with the artist until his last days. Leonardo was developing a new and distinct style of painting. Very much in the same way as his aristocratic patrons used him as an extension of themselves and an instrument of their will, Leonardo used his assistants to work on the images he had conceived and outlined.

Leonardo's views on painting are rooted in Verrocchio's workshop practice and the humanistic art theory expounded in Alberti's treatise on painting, the 1436 *Della pittura*. The compilers of the *Trattato* reshuffled Leonardo's notes across eight different headings;[8] the main thrust of his thoughts and ideas, however, fits within three broad categories: construction of the human figure, representation of space, and mental training and preparation.

THE COURSE OF STUDY

According to Leonardo, 'the painter's primary intention is to make a simple flat surface appear to be a raised body that stands out from that surface.'[9] It could be said that the entire course of study which Leonardo designed was dedicated to achieving this goal.

The organization of the notes on painting follows the standard sequence of training characteristic of Tuscan workshops, with the difference that Leonardo adapts, develops and expands the humanistic theory of painting to the workshop

practice.[10] Leonardo's apprentice is first given some basics of geometry and linear perspective through copying from respected antique and modern artists as well as from nature.[11] He then learns basic anatomy with a view to developing the necessary mental skills to depict any human figure in any imaginable position without looking at or copying a model.

Leonardo followed the traditional Renaissance approach to imagining and constructing the human figure in terms of bones, muscles, flesh and cloth. We encounter this approach already at the beginning of the fifteenth century in Alberti's text, the first modern treatise on painting and which Verrocchio and Leonardo knew very well. For Alberti as for Leonardo, the greatest achievement of a painter is the *historia*, best translated as a narrative composition of figures. Its main attributes are variety and abundance in terms of age, gender, social status and emotions. To quote Leonardo:

> In *historie* there should be people of varied complexions, stature, skin colour, postures, corpulence, thinness, big, delicate, tall, tiny, fat, slim, fierce, civil, old, young, strong and muscular, weak and with few muscles, cheerful, melancholy, and with curly and straight hair, short and long hair, who move quickly and languidly, and with similarly varied dress and colours, and whatever else the *historia* requires.[12]

Translating this into painterly practice meant treating anatomy as the gateway to the representation of movement. For Leonardo, each position of the body affects the distribution of weight over the limbs, alternatively stretching or compressing

the muscles and organs. Thus, once the student has developed
a personal style from copying ancient and modern masters,
and repeatedly drawn and absorbed human anatomy, he is
ready to express movement.

Leonardo realized that not only is the face a centre of
expression but so too is the entire body. He enjoins his appren-
tice to always keep a sketchbook by his side and to observe
the spontaneous actions and bodily expressions of humans
in public and private spaces:

> note them down with a brief indication of the forms;
> thus for the head make an 'o', for an arm a straight or
> a bent line, and the same for the legs and the body,
> and when you return home work out these notes in
> a complete form.[13]

The sketchbook is also a means of collecting a repertoire of
facial features:

> if you want to acquire facility for representing the
> expression of a face, first make yourself familiar with a
> variety of [forms of] several heads, eyes, noses, mouths,
> chins and cheeks and necks and shoulders: And to put
> a case: Noses are of 10 types: straight, bulbous, hollow,
> prominent above or below the middle, aquiline, regular,
> flat, round or pointed . . .[14]

Leonardo's sense of the human figure also entails notions
of weight and balance. The body is to be understood and rep-
resented with attention to the various pressures and muscular

contractions generated by the way movement affects the distribution of weight over the limbs. Movement, in other words, is expressed through the relation between weight and posture, a subject on which the *Trattato* offers much advice. These principles guide Leonardo's anatomical studies, which frequently show the same figure from different angles and display the ways in which bodily positions affect the appearance and position of muscles (illus. 13). Here, in a study dated 1508, the figure on the right-hand side, with its raised arm, anticipates the *St John the Baptist* (see illus. 63). Leonardo drew and studied anatomy all his life. Typically he went far beyond what he needed to know to depict anatomically correct figures; using drawing as a gateway to science, he also drew and investigated subjects such as the reproductive system and the circulation of blood in the human body.[15] In one study, a cross section of a head, he associated the shape of the brain with the morphology of onions (illus. 14).

The second part of Leonardo's course of study relates to colour and optics. It can be broadly subdivided into three branches: linear perspective, which controls the relationship between distance and proportion; colour perspective, which relates to the diminution in terms of focus and colour generated by distance; and finally light and shade, that part of optics which deals with the reflection of colours from one object to another. The latter is the source of Leonardo's main innovation, the so-called *sfumato*.

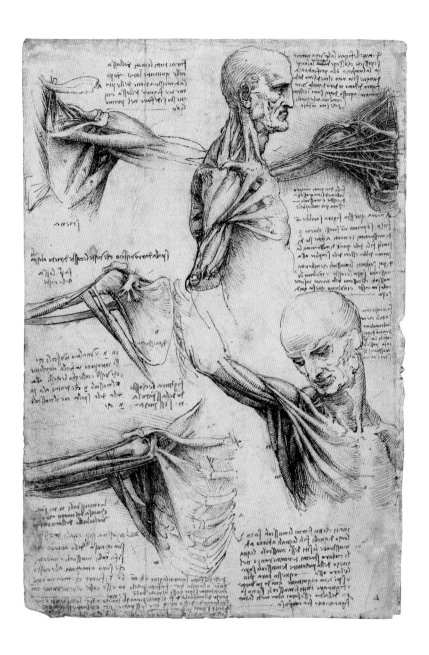

13 Leonardo da Vinci, *Anatomical Study*, c. 1510–11, pen and ink with wash over black chalk.

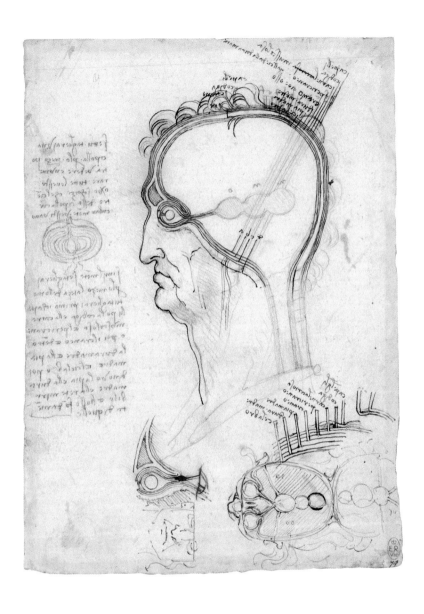

14 Leonardo da Vinci, *Sections of the Human Head and Eye*, c. 1490–92, red chalk, pen and ink on paper.

EXERCISES

Among the most interesting aspects of Leonardo's notes are
the exercises he gave to his students and in all likelihood
practised himself. Some serve to sharpen perception and
judgement, others aim at shaping the mind and the self. They
are precious hints of how Leonardo shaped his own self and
of how he conceived of painting as an autonomous activity
concerned with understanding the world, from inner emo-
tions and feelings to landscapes and rocky formations, clouds
and winds.

One exercise is very much reminiscent of the volumetric
imagination of Florentine merchants, who measured ware-
houses by gauging how many barrels would fit in a given
space.[16] Leonardo adapted this habit to imagine and measure
space; the exercise he devised consisted in evaluating the cor-
rect distance of objects placed in foreshortened view: 'that is,
take a spear, or any other cane or reed, and fix on a point at
a certain distance; and let each one estimate how many times
he judges that its length will go into that distance.'[17]

In a typically Florentine spirit of emulation, he enjoins
students to draw together and criticize each other.[18] The
sketchbook he always carried is a repository of observations
and a repertoire of models:

Once you have learned perspective well, and have
memorized all the parts and bodies of things, it is often
nice when you go for a walk to meander, in order to
see and consider the positions that people assume when
they speak, or argue, or laugh, or come to blows with

one another — and what their movements are, and what movements the bystanders, non participants, and onlookers of such things make. Jot brief notations in your tiny notebook, which you should always carry along... they should be preserved with maximum care, because things have such infinite shapes and movements that memory is not capable of retaining them.[19]

Probably the most famous exercise is a mind-expanding practice designed to stimulate the imagination:

it is very useful in arousing the mind [*ingegno*] to a variety of inventions . . . if you look at stained walls or mottled stones, in them you may be able to see inventions and likenesses of different landscapes, different battles, the dynamic actions of figures, strange facial expressions and dress, and infinite other things, because the *ingegno* is aroused to new inventions by indeterminate things. And these appear on such walls confusedly, like the sound of bells in whose jangle you may find any name or word you choose to imagine.[20]

Although Leonardo's approach is one of developing and expanding imagination, he also submits the imagery produced to a strict control, ensuring its uniformity. This process of learning through selecting and combining the best parts of antique and modern works of art was also expected to produce a certain ideal by which the physical irregularities of humans would be smoothed out and given a symmetry that might be absent from reality but pleasing to the eye and brain.

One first step in this direction is the use of a mirror as a means of correcting one's drawings. And indeed, things drawn do not look always quite as balanced and symmetric when seen in a mirror; Leonardo recommended: 'compare the reflected image with your picture and consider whether the subject of the two images duly correspond in both, particularly studying the mirror.'[21] It is not clear how extensively Leonardo used this method, yet some of his figures, the *St Anne* and the kneeling *Leda* for example (see illus. 52, 46), are mirror reflections of each other and bear witness to the fluency he acquired in imagining in three dimensions and mentally reversing images.

Leonardo's approach to correcting images depends not only on training the eye and its judgement but also on the sharpening of a sense of self-observation:

> A painter who has clumsy hands will paint similar hands in his works, and the same will occur with any limb, unless long study has taught him to avoid it. Therefore, O Painter, look carefully what part is most ill-favoured in your own person and take particular pains to correct it in your studies. For if you are beastly, your figures will seem the same and devoid of charm; and it is the same with any part that may be good or poor in yourself; it will be shown in some degree in your figures.[22]

Thus self-observation is essential if one is to correct the shortcomings of one's own work, in relation to the ideal acquired through synthetic imitation. This advice has been interpreted as a reaction to the works of contemporaries of

Leonardo such as Botticelli and Perugino, whose figures, based on workshop templates, tend to look indistinguishable from one another.[23] Leonardo refers both to physical and psychological shortcomings. He speaks first of hands and limbs, but also of the mind when he writes 'se sarai bestiale le tue figure paranno il simile' (if you are beastly your figures will seem the same as you). Here *bestiale* is both a psychological and a physical attribute.

One implication of this method is that correcting one's painting would also serve, at least mentally, as a first step towards identifying and correcting one's own shortcomings. In fact this stage of self-shaping features in Leonardo's thought as an intermediate stage between using a mirror as a guide and becoming oneself a mirror in order to reflect the world, without the deforming lenses of human quirks and defects:

> The mind of the painter must resemble a mirror, which always takes the colour of the object it reflects and is completely occupied by the images of as many objects as are in front of it. Therefore you must know, O Painter! that you cannot be a good one if you are not the universal master of representing by your art every kind of form produced by nature.[24]

Leonardo's practice of painting goes hand in hand with a standard conception of perception and visualization as based on the activity of four faculties located in three ventricles of the brain: common sense, fantasy, imagination and memory (see illus. 14). To perceive is to receive sensory impressions

through the common sense, to hold them in the *fantasia*, to process them into intelligible multi-sensory images by means of the imagination, and to store them in the memory for future retrieval. To visualize is to imagine and recompose these images.[25]

Thus visualizing figures in terms of movements, emotions, expressions and space is the mental discipline necessary to produce a *historia*. Within this framework and through this ingenious use of the plasticity of artistic media and the powers of observation and self-observation, Leonardo was creating a new style as much as he was fashioning his own self.

FROM IDEAL TO HUMANITY

The Vitruvian Man (illus. 15) is Leonardo's manifesto of the ideal figure and the outcome of his interest in human proportions and in geometry. The economy and elegance of lines together with the intense symbolic density of the square and the circle in which the figure fits so perfectly have made this image one of the most iconic in the world. In parallel with this work of idealization Leonardo produced images enhancing human ugliness and deformities. These range from doodles to finished drawings, and their appellation of 'grotesque heads' is a category devised by scholars to classify those of Leonardo's drawings that feature physiognomic exaggerations. Some were initially seen as fragments of a set destined to illustrate a projected book on physiognomy, others as naturalistic representations of real people suffering from real diseases. It has also been suggested that the theory of the four temperaments and their physiological variety guided his approach – although

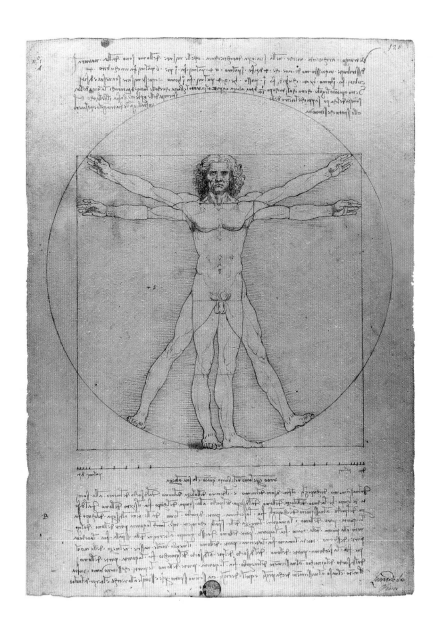

15 Leonardo da Vinci, *Vitruvian Man*, c. 1490, pen and ink over grey-washed paper.

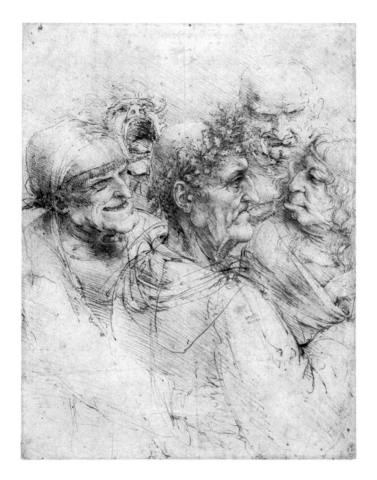

Leonardo is not particularly systematic.[26] Ernst Gombrich associated certain of these doodles and self-portraits with Leonardo's mode of depicting soldiers.[27] More recently, Martin Kemp has set these drawings in the context of court entertainments and connected them to the characters of the comic world of the *novelle*, an Italian tradition of short stories inaugurated in the fourteenth century by Giovanni Boccaccio's

16 Leonardo da Vinci, *Study of Five Grotesque Heads*, *c.* 1494, pen and ink on paper.

Decameron, the foundation stone of Tuscan prose, which was well alive in Leonardo's time.[28]

The composition with five heads (illus. 16), sometimes seen as a classical profile surrounded by four mocking figures,[29] is a study depicting the human face from five different angles. The crown of oak leaves, an ancient military distinction, designates

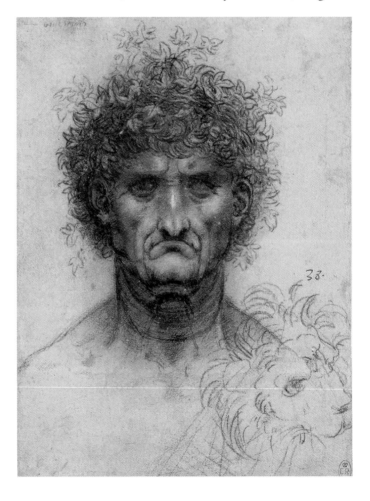

17 Leonardo da Vinci, *Old Man and Lion's Head*, *c.* 1505–10, red chalk with white heightening on pink prepared paper.

the central character as an ageing soldier. Leonardo seems to have enjoyed drawing people of this particular class, perhaps because of his involvement with the military world. Some images are neither portraits nor complete exaggerations, as for instance the red chalk study of a man's head with asymmetrical ears (illus. 17). The seamless morphing of his bushy head of hair into leaves somehow conveys the character of a tree trunk to the powerful neck of the sitter. These leafy curls as well as the strong furrows between the eyes also invite comparison with the lion's head sketched on the right-hand side. The lion's head is placed like the shoulder pad of a typical Renaissance suit of armour and would therefore allude to the military status of the sitter. While the whorls of ivy crowning the man's head are a standard attribute of Bacchus, the lion is not, and neither is the sad expression of the mouth. If anything, the drawing illustrates Leonardo's combinatory use of a repertoire of vegetal, animal and human forms.

APPLICATIONS

Leonardo's first large commission as an independent painter was the *Adoration of the Magi* (246 × 243 cm/97 × 96 in.) for the Augustinian church of San Donato a Scopeto, near Florence (illus. 18). Since Leonardo's father had notarial business with the monastery attached to the church, it has been speculated that he had a hand in securing the commission for his son.[30] Like the *St Jerome* (illus. 19), the *Adoration* is unfinished as Leonardo was sent to Milan before he could complete them. Both works contributed to his growing reputation for never finishing what he started, but they also have the advantage, from our

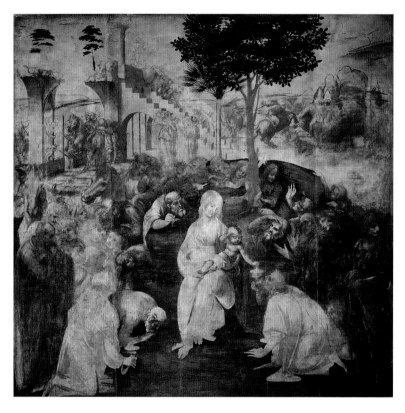

present point of view, of serving as snapshots of how he began a painting by laying out areas of light and shade. The *St Jerome*, one of Leonardo's first experiments with rocky formations, illustrates how he built human figures as bones, muscles and flesh and painted them from the head downwards.

The *Adoration of the Magi* is far more ambitious than the *St Jerome*. The subject itself offered far more scope for the expression of Leonardo's talent in terms of size and the number of interacting figures. In fact a close inspection reveals this work as a visual distillation of Leonardo's ideas and *savoir faire* (see

18 Leonardo da Vinci, *Adoration of the Magi*, c. 1481–2, charcoal, watercolour ink and oil on wood.

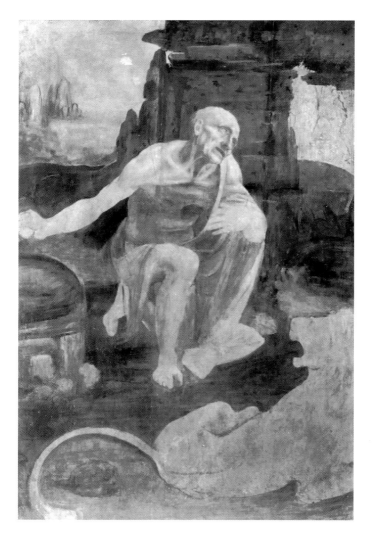

illus. 18). The young Leonardo evidently decided to become the greatest painter of his time and packed into this work everything he knew in terms of preparation, distribution of light and shade, perspective, and the composition of figures

19 Leonardo da Vinci, *St Jerome*, 1480–82, oil and tempera on walnut.

of different ages, gender and social position expressing a wide variety of emotions. The painting contains some references to antique art; for instance, the figure sketched in profile on the stairs towards the centre-left of the image derives from antique sculptures of river gods. The two masculine figures flanking the composition at each side are adapted from the moderns, in this case Masaccio and Donatello. These stand as visual evidence of the standard method, advocated by Leonardo, of learning by initially copying from antique and modern art to develop a personal vocabulary and style. In the background the horse and riders are earlier versions of those that Leonardo would later paint for the *Battle of Anghiari*.

Leonardo's ideas and skill produced paintings that became emblematic of the Renaissance obsession with life. The idea of art making things look alive features in just about every Renaissance poem in praise of painting. One of the reasons behind Leonardo's success is precisely the quality of life he brought to his figures, which reaches its peak in the *Mona Lisa* (see illus. 55). Similarly, his religious works were received with considerable enthusiasm. Religious images, however, are made for worship rather than for pleasure or remembrance, and as we shall now see, Leonardo showed much discomfort with the question of the worship of images.

ICONOGRAPHY, ART AND RELIGION

While some scholars have read religious intentions in Leonardo, most have observed that he had only limited interest in the subjects he was commissioned to depict.[31] Until the eighteenth century, works of art were invariably commissioned as well

as serially made on the basis of conventional subject-matter – such as the Madonna and Child, the Crucifixion, the Resurrection and so on – each offering different pictorial possibilities. Leonardo's output was mostly religious, yet his notes on painting contain hardly any references to religious subjects, and his literary remains display more annoyance with monks and priests than interest in religious matters. Indeed his detachment from the subject finds confirmation in his view, quoted above, that the prime intention of the painter is to make a figure stand out on a flat surface.

Leonardo might have painted mostly religious subjects, but the few allusions to religion in his writings reflect annoyance with and disapproval of beliefs and practices surrounding the cult of images. In one of the most oft-quoted passages of his notes he attributes the cause of pilgrimage to the outstanding character of images and therefore to the talent of painters. These comments, which have often been taken at face value, sound particularly ironic when placed in their historical context.

In the fifteenth century people neither travelled nor queued to see outstanding pictures. Art-oriented tourism and pilgrimage were later phenomena, and mass tourism to blockbuster exhibitions began only in the twentieth century. Leonardo knew very well that pilgrimages were not primarily conducted to view works of art but to visit and benefit from specific places, relics and miraculous images. He must have also known that the class of images worshipped by pilgrims, such as the Black Virgin of the Santa Casa in Loreto, or the wooden statuette for which his own *Virgin of the Rocks* might have served as a screen, were closer in appearance to totemic deities than to

the idealized figures he was producing.[32] Furthermore, he characterized worship as idolatry, since worshippers assume an image to contain what it represents. He writes of how the people 'who have flocked there throw themselves to the ground worshipping and praying to Him whose image is represented for the recovery of their health and for their eternal salvation, as if the Deity were present in person'. He suggests the cause to be the merit of the painter:

> And what necessity impels these men to go on pilgrim-ages? You surely will agree that the image of the Deity is the cause and that no amount of writing could pro-duce the equal of such an image either in form or in power. It would seem, therefore, that the Deity loves such a painting and loves those who adore and revere it and prefers to be worshipped in this rather than in another form of imitation; and bestows grace and deliverance through it according to the belief of those who assemble in such a place.[33]

Excusing idolatrous behaviour by painterly talent could well be playful, but the passage is also a hostile characterization of image worship. Leonardo's annoyance also features in one of the riddles he composed, one that presents the worship of images as an irrational and foolish behaviour:

> Men will speak to men who will not feel, they will have open eyes and will not see, men will speak to them, but they won't make any answer, they will ask grace to those who have ears but won't hear, they will make

light, but only for the blind. The answer is: worshipped pictures of saints.[34]

These observations on the cult of images, made for the amusement of the entourage of the Duke of Milan, again anticipate by only a few years some of the main attacks on images characteristic of the Reformation: people are worshipping pieces of dead matter as if the deity were present in them. Also although of course Leonardo painted many Madonnas, another riddle may suggest that he also shared with the Reformation a disinterest in the image of the Virgin, and a dislike for her cult: 'Who are those', he asks, 'who hold the faith of the son, but only build temples in the name of the mother?' Christians.[35]

More singular is a fragment, published by Jean Paul Richter under the heading of Leonardo's 'jests and tales', that tells the story of a priest who on Easter Eve was sprinkling holy water in the house of his parishioners. In the process he sprinkled a painting in a painter's workshop: 'The painter turned round, somewhat angered, and asked him why this sprinkling had been bestowed on his pictures.' The priest responds that

> he was doing good and that he who did good might look for good in return, and, indeed, for better, since God had promised that every good deed that was done on earth should be rewarded a hundred-fold from above. Then the painter, waiting till the priest went out, went to an upper window and flung a large bucket of water on the priest back, saying: 'here is the reward

a hundred fold from above, which you said would come from the good you had done me with your holy water, by which you have damaged my pictures.'[36]

This anecdote is interesting on many levels. At a technical level, although Leonardo was painting with oil – on which the droplets would have merely slid – he was still thinking of painters as using water-soluble media such as tempera. But regarding his stance towards religion, the violence of promptly filling, rushing upstairs and throwing a bucket of water in retaliation for a mere sprinkle of holy water seems somehow overreactive. Apart from 'de-sacralizing' both the holy water and the painted surface, this anecdote, together with Leonardo's negative characterization of image worship, anticipates some core ideas of the Reformation. Here the faith that good deeds are always rewarded and can consequently be performed as investments in one's future is ridiculed. Only a few years later, in 1517, Martin Luther, who inaugurated the Reformation, would claim just the same: that good deeds do not guarantee salvation. Leonardo's dislike of idolatrous worship sets him in convergence with the elites of his time who, like Erasmus of Rotterdam (1466–1536), shared an increasing dislike for the cult of the Virgin and of saints, in which they discerned remnants of pagan polytheism.

While embracing ideas circulating in his time, Leonardo also had the experience of witnessing his work adulated to excess, such as for instance a cartoon comparable to the so-called *Burlington House Cartoon* (*Virgin and Child with St Anne and St John the Baptist*, see illus. 51), exhibited for two days in a Florentine church. According to Vasari, the work prompted

such fervour that 'men and women, young and old, continued for two days to flock for a sight of it to the room where it was, as if to a solemn festival, in order to gaze at the marvels of Leonardo, which caused all those people to be amazed.'[37] Vasari attributes this fervour to the beauty and expressivity of the figures, yet Leonardo might have been particularly annoyed to see people kneeling, mumbling, praying and crying in front of his work.

Reactions to Leonardo's work were also a response to the qualities of naturalness and liveliness – the most sought-after aspects of Renaissance art – that he has worked so hard to infuse into his painting. But if Leonardo made religious figures so deeply real as to generate idolatry, what would he have done, we might ask, with pagan figures? Strangely enough, all his autograph works made after antique subjects have been lost – some completely, and some known only through second-rate copies. The centuries that separate us from Leonardo were marked by religious fanaticism, both in Italy and France, and one can conjecture that his depictions of the mythological figures of Leda, Bacchus, Hercules and Neptune brought so much life to pagan deities as to prompt unfortunate zealous destruction during the century of the Counter-Reformation.

Did Leonardo's ideas on religion affect his paintings? One formal change is the way in which he separated the viewer from the figures by a ditch in the two versions of the *Virgin of the Rocks*, the *Burlington Cartoon* and the *Virgin and Child with St Anne* (Louvre, *c.* 1503). These religious works from the period of his maturity precisely differ from the early Madonnas with their parapets intended to invite the viewer to extend his own space into the pictorial one.

This sense of distance and detachment brought by Leonardo's formal solution also rings true in terms of his general approach to the world. His imagination is rich, intense and powerful, but it lacks the empathic aspects of medieval devotion. In this respect Leonardo could not be more different from Fra Angelico (1395–1455). If we are to believe Vasari, Fra Angelico, a model Christian painter and Dominican monk, empathized so much with the subjects he depicted that he frequently cried during their making – especially, it is said, while painting the Crucifixion. Leonardo never painted a Crucifixion, but had he done so, he would probably have spent weeks on end drafting anatomical studies on the effects of stretching on bones, muscles and sinews. He would not have empathized with the emotions of individual figures but would instead have made himself the mirror of the scene.

Milan, 1483–99

lorence and Milan were allies throughout the 1470s, and already in 1473 the rulers of Milan, the Sforza, were looking for someone to produce an equestrian monument celebrating Francesco Sforza, the founder of their dynasty.[1] They turned to Lorenzo de' Medici for recommendations. Antonio del Pollaiuolo provided some drawings by 1476, but the project lingered until 1482, when Lorenzo recommended and sent Leonardo, who, as the star pupil of Verrocchio, had sufficient credentials to cast a monumental bronze horse and its rider.

According to one of Leonardo's earliest biographers he 'was 30 when he was sent by . . . Lorenzo to the Duke of Milan, together with Atalante Migliorotti to present him a lyre, which he played like no one else'.[2] Leonardo would spend eighteen years in Milan. There he fashioned himself and bloomed as a Renaissance courtier and court artist while expanding his research and work in painting, sculpture, anatomy, hydraulics and military engineering as well as scene design.

From about the fourteenth century onwards, the position of court artist began to emerge as an alternative to the traditional place of the artist within the urban workshop environment. Instead of working as workshop masters and managers,

artists became employees of the court and were sometimes admitted to the close entourage of the ruler as *familiari*. This slow financial and social ascension led artists to claim equal status with other court employees such as poets, mathematicians, astrologers, musicians, philosophers and physicians, with whom they often collaborated.[3] From the 1430s onwards, humanistic art theory asserted that painting, sculpture and architecture were liberal arts; in other words, artists claimed for their profession the status of an intellectual pursuit practised for the acquisition of knowledge and wisdom rather than for income – just like the other liberal arts of grammar, rhetoric, logic, geometry, arithmetic, music and astronomy, which were the foundations of upper-class education. At the time these aspirations were partly wishful thinking – for instance, the idea of teaching the visual arts in universities would have been met with derision. Artists came from the artisan class and well into the seventeenth century did not have any Latin, the language of learning and power that was taught, written and spoken in universities, at church and in courts of law.

There could be no better environment than the court for Leonardo, who himself contributed to defending and promoting the intellectual status of the artistic profession in the context of courtly entertainment. Verrocchio's relationship to the Medici had fully prepared Leonardo for this new environment. Although Florence was still at the time a republic and the Medici their leading faction, they treated Verrocchio as their court artist, alternatively commissioning from him baptismal fonts, bells, paintings and sculptures, portraits, tournament banners and funerary monuments. It could be said that the function of the court artist was to express, in

multiple mediums, the power and magnificence of the ruler. In this respect, fifteenth-century Medici patronage became a model of magnificence which other rulers of the Italian peninsula subsequently adopted. Lorenzo's allies frequently turned to him for advice and recommendation in matters of art and artists. Sending Florentine artists to other city-states was for him a way of promoting Florentine art and of using artists as pawns in the complex net of diplomatic relations between the rulers of the Italian peninsula.[4]

During the first seven years of his stay, Leonardo mostly worked as a painter. He set up a workshop to honour the first commission he received thanks to Sforza's influence – the *Virgin of the Rocks*. He hired and directed some assistants. At the same time, Leonardo began accessing the court, of which he became a salaried member from 1490 onwards.

SELF-FASHIONING

Leonardo's first Milanese period is one of personal transformation, outstanding achievements and stellar social ascension. Until his arrival in Lombardy, Leonardo had merely grown up in the company of peasants and artisans, with occasional access to the bourgeois world of his father and the elite world of the Medici sculpture garden. Life in Milan propelled him to the courtly universe in which he would flourish for the rest of his life. The first known records of Leonardo's physical appearance date from these times. The elegant yet unfinished *Portrait of a Musician* of 1485 (illus. 20) has sometimes been identified as a self-portrait. Whether or not this is the case, it certainly coincides with contemporary descriptions of

Leonardo, not as a painter or an artisan, but as a gentleman of outstanding skill and considerable charm. According to the brief biography provided by the historian Paolo Giovio (1483–1552), who knew Leonardo personally from his stay in Milan,

> His mind was of a delightful brilliant and generous cast, his face outstandingly pleasing; since he was a marvellous inventor and judge of all sorts of amusements and distinguished pastimes, especially of pageants, as well as an expert singer who accompanied himself with the lyre, he was a favourite of the princes of his time.[5]

Giovio also knew Vasari, whom he had encouraged to write the *Lives of the Artists* and with whom he might have shared Milanese memories of Leonardo. In the 1540s, when Vasari was preparing his *Lives*, he had access to many people who had known Leonardo personally, including his closest pupil, Francesco Melzi. Thus Vasari's evocation of Leonardo converges with Giovio's, but with more detail:

> besides a beauty of body never sufficiently extolled, there was an infinite grace in all his actions; and so great was his genius, and such its growth, that to whatever difficulties he turned his mind, he solved them with ease. In him was great bodily strength, joined to dexterity, with a spirit and courage ever royal and magnanimous.[6]

According to his early biographers Leonardo was also an accomplished musician, singer and dancer. Vasari adds that

he was eloquent and sported an aristocratic lifestyle in spite of his modest origins: 'He was so pleasing in conversation, that he attracted to himself the hearts of men. And although he possessed, one might say, nothing, and worked little, he always kept servants and horses.'[7]

Vasari and Giovio distinctly echo the Renaissance conception of the ideal courtier, which Baldassare Castiglione elaborated and defined in his *Il cortegiano* (Book of the Courtier, 1528), one of the most influential books of the time (illus. 21).

According to the standard scholarly narrative, Castiglione's *Cortegiano* is a witness of the slow political and social changes which by the end of the fifteenth century had turned the old medieval aristocracy into a court aristocracy. This transition from the medieval knight-warrior to the court gentleman affected aristocratic manners and behaviours. Thus the *Cortegiano* has been identified as a decisive step in the civilization process that eventually shaped European identity.[8]

In contrast to manners perceived as medieval, rustic and brutal, the *Cortegiano* provided a model of courtly conduct to the European elites destined to serve in the entourage of kings and rulers. The *Cortegiano* was useful not only for the Renaissance nobility but for all the members of the broader princely entourage, including physicians, mathematicians, astrologers and artists. They all aspired and competed to achieve the main purpose of the perfect courtier: to win the soul and the benevolence of the ruler.[9]

Written between 1508 and 1527, Castiglione's *Cortegiano* offers an intimate and exquisite view of the world of the Renaissance courts in which Leonardo evolved from the 1480s onwards. Castiglione served the Duke of Milan from 1496 to

1499 and knew Leonardo personally. He mentions him as among the best painters of his century and also repeats some of his views on the comparison between painting and sculpture which Leonardo had debated in a courtly entertainment.[10] Leonardo himself most probably served as a building block

20 Leonardo da Vinci, *Portrait of a Musician*, c. 1485, tempera and oil on wood.

in Castiglione's construction of the ideal courtier, especially as he mastered the many skills required of an ideal courtier. Furthermore, Vasari's evocation of Leonardo quoted above implies that he embodied the attributes of ease and facility encapsulated in Castiglione's innovative concept of *sprezzatura*, a term that appears for the first time in the *Cortegiano*:

21 Raphael Sanzio, *Baldassare Castiglione*, c. 1514–15, oil on canvas.

But having before now often considered whence this grace springs, laying aside those men who have it by nature, I find one universal rule concerning it, which seems to me worth more in this matter than any other in all things human that are done or said: and that is to avoid affectation to the uttermost and as if it were a very sharp and dangerous rock; and, to use possibly a new word, to practice in everything a certain *sprezzatura* that shall conceal design and show that what is done and said is done without effort and almost without thought. From this I believe grace is in large measure derived, because everyone knows the difficulty of those things that are rare and well done, and therefore facility in them excites the highest admiration; while on the other hand, to strive and as the saying is to drag by the hair, is extremely ungraceful, and makes us esteem everything slightly, however great it be.[11]

This so-called grace, to which Castiglione gave the name *sprezzatura*, is pretty much the same as the '*virtue*' mentioned by Vasari: 'that whenever his mind focused on difficult things, he solved them with ease'.[12]

Could Leonardo have fashioned himself in a way that brought *sprezzatura* as a dominant quality both in his art and in the image he projected to his contemporaries? Leonardo could easily learn the art of shaping himself into a perfect courtier, as it was similar to that used for the acquisition of artistic skills. As we have seen in the preceding chapter, artistic style took shape through the process of observing, selecting and absorbing the works of ancient and modern masters.

Similarly, the elaboration of a courtly self resulted from a process of selective imitation, which Castiglione presented through the pre-modern biological example of the bees and the confection of honey:

> And as the bee in the green meadows is ever wont to rob the flowers among the grass, so our Courtier must steal this grace from all who seem to possess it, taking from each that part which shall most be worthy praise.[13]

Castiglione's ideal *cortegiano* is one constantly in movement, and his aura of *sprezzatura* is an expression of the movements of the mind and of the body. It particularly blooms in courtly pastimes, a genre both entertaining and intellectually stimulating. Castiglione's depiction of the pastimes of the court of Urbino, domain of the House of Montefeltro, coincides with many of Leonardo's activities in Milan:

> among the other pleasant pastimes and music and dancing that continually were practiced, sometimes neat questions were debated, sometimes ingenious games were devised at the choice of one or another, in which under various veils the company disclosed their thoughts as allegories to whom they liked best. Sometimes other discussions arose about different matters, or with to and fro quick-witted biting. Often devices (*imprese*), as we now call them, were made, and marvelous pleasure was taken from these conversations, as the house (as I have said) was full of very noble minds.[14]

We know that Leonardo could play music, sing and dance. The prophecies and riddles he composed fit neatly under Castiglione's heading of 'ingenious games . . . in which under various veils the company disclosed their thoughts'. The 'prophecies', composed with a view to performance, are riddles playfully worded in prophetic language. They relate to animals, plants, ceremonies, manners, quarrels and paradoxes.[15] For example: 'the natives of the waters will die in boiling food' (that is, boiled fish).[16] Or: 'A great part of the sea will fly towards heaven and for a long time will not return' (namely, clouds).'[17] The 'prophecies' related to manners and ceremonies tend to highlight Leonardo's anti-clerical spirit, while those related to animals sometimes mention the oddity of eating animals: 'The masters of estates will eat their own workers' (that is, oxen).[18]

The animal fables follow the medieval and antique tradition of using animals as emblematic of things such as love, envy, avarice, gratitude, foresight or magnanimity. Leonardo's interest in the texture and consistency of hair may have inspired him to write a fable on a flea leaving the skin of a dog attracted by the deep, warm curls of a sheep, where it died of hunger, unable to reach the skin.[19] The elements can speak and act, too. Water wanted to rise above itself and thus turned into vapour, reaching up high; but it then reverted to its liquid state and fell upon the dry earth, where it remained a prisoner as a punishment for its immodesty. Objects also exhibit behaviours: the razor that thinks it will remain shiny in its sheath, eventually rusts and loses its edge. The same happens, Leonardo warns, to those who give themselves to sloth. Like the razor, they will lose the sharpness of their wit and spoil their

shape with the rust of ignorance.[20] The flame of a furnace abandons its sisters to glow on a candle, mounted on a beautiful and shining candlestick, but dies in foul smoke (*fastidioso fumo*). A pear tree expresses pride to be sculpted into an image of Jupiter.[21]

Among the other pastimes mentioned by Castiglione, devising and drawing *imprese* was a common duty of court poets and artists. An *impresa* is a compound of text and image expressing a concept. As personal emblems, *imprese* were often worn on the head as hat jewels, a fashion introduced into Italy by the entourages of the French kings. They also feature in tournaments, where they serve to identify each participant. Verrocchio designed some personal emblems for the Medici, perhaps with the assistance of Leonardo, who in turn invented several of those for Ludovico Sforza, Duke of Milan, also known as 'il Moro' because, it is said, of his dark complexion, and later for Cesare Borgia and the French king Francis i, who had him personally paint his tournament gear – which is unfortunately lost.

COURTLY DISPUTATIONS

The art of the disputation, mentioned by Castiglione, has a long history both in higher education and courtly entertainment well before and after Leonardo. Initially devised as an exercise for the practice and improvement of eloquence, in the courtly world such debates focused on mundane questions such as whether it is better to love without being loved or to be loved without loving. Disputations on scientific subjects also feature as a form of court entertainment, such as the

debates organized in Milan for the pleasure of Ludovico Sforza and his court in the 1490s.[22] Leonardo actively contributed to these events. His most important intervention concerns the *paragone*, or comparisons and rivalry between the arts. His views clearly made an impression on his audience, for even Castiglione includes the debate in his *Cortegiano*.[23] The question of whether painting is superior to poetry and to sculpture fits the didactic and entertaining requirements of the courtly debate. Leonardo's treatment of the subject inaugurated a series of disputes that took place throughout the sixteenth century.[24] His comparison of painting and poetry emphasizes the superiority of sight over hearing and the simultaneity of painting over the temporality of textual narration. In his last dispute he contrasts the universality and intellectual character of painting with the limited representational possibilities and work-intensive aspects of sculpture.

LEONARDO AND THE ACADEMIES

At court Leonardo was not only entertaining the Milanese *jeunesse dorée*. He also met scholars, with whom he collaborated, exchanged ideas and furthered his studies. These include the mathematician Luca Pacioli, the anatomist Marcantonio della Torre, the poet Bernardo Bellincioni, the musician Atalante Migliorotti, with whom he came to Milan, as well as all the staff involved in the preparation of courtly entertainments and festivals. A passage from a poem of Bellincioni celebrates the splendour of the Sforza court, which he compares to Mount Parnassus, sojourn of the gods of Graeco-Roman mythology, where the best men in poetry, medicine, science

and the arts come like bees to honey. Leonardo features as the Apelles from Florence.[25]

A series of undated prints, which Vasari attributes to Leonardo, somehow encapsulates this productive period of intellectual exchange, creative endeavour and artistic enterprise (illus. 22). They feature patterns of knots around a medallion with the Latin inscription 'Academia Leonardi Vi͞ci'. Vasari refers to them disapprovingly as a waste of time and does not comment on the possible existence of an academy around Leonardo.[26] Scholars have therefore hypothesized several scenarios, from the existence of a real academy to a mere invention.

Renaissance academies are a particular breed of institution. By the end of the fifteenth century, an academy was no more than a regular gathering grouping men of letters and ruling-class youth for the purpose of entertainment, very much as in Castiglione's *Cortegiano*. By the second half of the sixteenth century, however, academies were becoming formal institutions with rules, rituals, iconographies and hierarchies.[27] Their foundation myth is the Athenian academy of Plato (387 BC), revived in fifteenth-century Florence under the Medici. The language of the academy was the Italian vernacular spoken at court yet based on Tuscan literary models, and their most conspicuous iconography was the bee, whose selective and social behaviour served as a fictive biological model of academic ideals. Leonardo was undoubtedly acquainted with this culture through his earlier work in the Medici garden frequented by Ficino, Poliziano and Cristoforo Landino. Ficino in particular was seen as the artisan of the revival of the legendary Athenian academy,

having made available the complete works of Plato for the first time since antiquity.

All the activities in which Leonardo participated, from literary games to the organization of feasts, banquets and pageants, would later be associated with those of Renaissance academies. In fact, the dialogues of Castiglione's *Cortegiano* have been characterized as an embodiment of the academic ideal of conversation. A document recently rediscovered, the *Isola beata* (private collection, *c.* 1513) of the poet Henrico Boscano, describes in precise fashion the Milanese circle of court intellectuals to which Leonardo belonged as an academy – that is, an informal yet regular meeting of scholars, noblemen, scientists and artists.[28]

How the *Academia* prints relate to these informal meetings is not entirely clear, however. In the dedication of the *Isola beata* it is the author's house, rather than Leonardo's, that is described as 'the forge and cement of wise men and the academy of many lords, counts and cavaliers, philosophers, poets, and musicians'.[29] Thus if we cannot really ascertain that an academy took shape around Leonardo, it is at least established that he participated in one such group. Perhaps his work environment was also the setting of such informal meetings. One small hint of this is a fragment in his notes in which he discusses how shells found in mountainous areas are witnesses of the presence of the sea and of an antique deluge. He recalls: 'When I was making the great horse in Milan, a big bag [of shells and corals found in the mountains near Parma and Piacenza] was brought to me by some peasants.'[30] For the present purpose this anecdote suggests that the person who directed those peasants to Leonardo knew

that questions related to the origins of the world and traces
of the biblical Deluge were discussed in his quarters. Thus
this anecdote might be indirect evidence of informal reunions
that he decided to immortalize in a series of prints.

The knot prints, like every image, change meaning accord-
ing to context. In the example illustrated here, the interlacing
of six strings forms the whole pattern, while in other versions
the pattern is made out of eighteen and 31 single strings.[31]

22 Leonardo da Vinci, *Third Knot*, 1490–1500, print of a knot design,
with around the central circle the words 'Leonardi Academia' and in
the centre 'Vici'.

Perhaps this exercise relates to the academic ideal of collaboration, evoking the sense that the joint efforts of those involved produce a whole bigger than its parts.

23 Leonardo da Vinci, *Sala delle Asse*, c. 1496–7, fresco and tempera, Sforza Castle, Milan.

KNOTS AND PORTRAITURE

Knots and graphic patterns exercised an endless fascination on Leonardo that goes far beyond the borrowing of medieval ornamental motifs. He was particularly thrilled by the ways in which the movements of water and the flow of hair locks produce by themselves regular patterns of knots (see illus. 68). Knots feature also on the hem of the dresses of many of his figures. The *Salvator Mundi* displays a particularly flattened version of such a pattern (see illus. 57). There is also evidence that Leonardo designed a carnival dress which he decorated with a knot pattern stencil.[32] Another outstanding example of Leonardo's fascination with artificial and natural weaving patterns is the frescoes of the Sala delle Asse of the Castello Sforzesco of circa 1496–7 (illus. 23) – his last Sforza commission. One of the least studied of Leonardo's works, the ceiling of the Sala delle Asse represents the interweaving of the branches of sixteen trees across a vaulted ceiling with the joint arms of Ludovico Sforza and his wife, Beatrice d'Este, at its centre.[33] Thus nothing is really quite as 'natural' as it seems in Leonardo.

COURT PORTRAITURE

The portrait of Cecilia Gallerani (*Lady with an Ermine*, c. 1489–90, illus. 24) includes more playful variations on knots, from the patterns of the ornamental border of the dress, traced in light and fluid golden lines, to their loose black velvety versions in the laces tying Cecilia's sleeves.

The ermine she holds in her lap has many emblematic layers, referencing her name, her character and her relationship

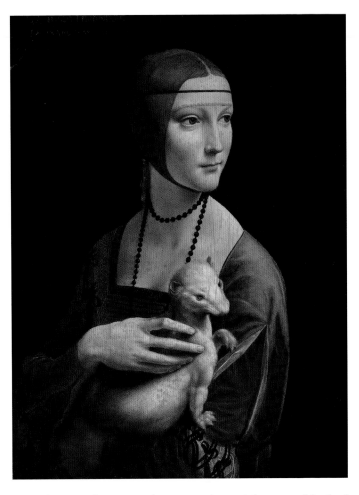

to Ludovico Sforza. Cecilia was Ludovico's lover, and he had to leave her to marry Beatrice d'Este in 1491, the same year Cecilia gave birth to their son, Cesare.[34] According to Pliny, and as illustrated by Leonardo, the ermine would rather let itself be killed by hunters than soil her immaculate fur; it was therefore represented as a symbol of purity (illus. 26).[35] Furthermore,

24 Leonardo da Vinci, *Lady with an Ermine*, 1489–90, oil on panel.

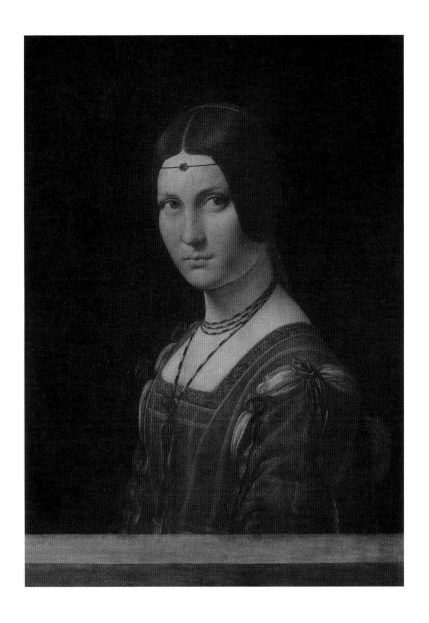

25 Leonardo da Vinci, *Lucrezia Crivelli*, 1490–96, oil on wood.

the Greek word for ermine, *galé*, puns with Cecilia's own name.[36] Several Renaissance images also testify to the belief that ermines would protect women during pregnancy, a time of high anxiety and cause of high mortality in those days. Cecilia and Ludovico's son, Cesare, also adopted the ermine as a personal emblem; thus its presence would also allude to him – especially since the specimen represented here is male, or at least appears so on account of its size.[37]

Thanks to the advent of amateur videography as well as the diffusion of wildlife documentaries online it can promptly be ascertained that no ermine, known also as the stoat or short-tailed weasel, is as graceful and tame as the one sitting

26 Leonardo da Vinci, *The Ermine as a Symbol of Purity*, c. 1494, pen and brown ink over slight traces of black chalk, on paper.

on Cecilia's lap. In spite of its classical and medieval symbolic pedigree this smallest of all carnivores is also a hyper-nervous, aggressive, food-driven killer which needs to eat half its weight in food every day and immobilizes its prey, from mice to hares and hens, by piercing the skull with its sharp front teeth before sucking the brain.[38]

Ermines are far too agitated to sit on anyone's lap like a baby in a Madonna and Child – a standard compositional model Leonardo probably had in mind when painting this work and on which he produced endless variations. Yet the soft curves of the ermine, which by themselves are a natural yet furry type of *sfumato*, placed next to Cecilia's exquisite hand express Leonardo's intuition of a continuity between the human and the natural world. This artificial juxtaposition of human and animal forms is the outcome of a distillation process in which Leonardo picks, chooses and adapts natural elements to create images that satisfy his own standards, guided by the ideals of grace and effects of *sprezzatura*. What he does with Cecilia and his reworking of the ermine continues in the world of sensitive beings what he did in the world of knots and natural patterns of growth and flow: build a vocabulary of visual rhymes based on idealized natural shapes.

Faithful to his own precepts on the construction of the figure, Leonardo has oriented each element of the picture – Cecilia's arms, hands and head, the ermine's body and head – at different angles in relation to the plane of the picture. Leonardo applied the same principle in his other female portrait of these years, that of Lucrezia Crivelli, another mistress of Ludovico (illus. 25). There, behind a parapet, the sitter gently turns her head and looks towards the viewer while the curves

of her necklace define the volume and roundness of her neck and her torso clad in crimson velvet. This arrangement, often associated with the practice of sculpture, is primarily an example of the three-dimensional thinking common to painting and sculpture as much as an application of Leonardo's definition of painting as the art of turning a flat surface into a raised body.[39]

THE *VIRGIN OF THE ROCKS*

The *Virgin of the Rocks* was the first major commission Leonardo received in Milan, probably thanks to the intervention of Ludovico Sforza (illus. 27). The painting would decorate the newly built chapel of a lay confraternity attached to the Franciscan Milanese church of San Francesco Grande (destroyed in the eighteenth century). Leonardo and two Milanese painters, the brothers Ambrogio and Evangelista de Predis, were entrusted with three panels to be inserted in a larger altarpiece dedicated to the main theme of the chapel: the Immaculate Conception. Leonardo's painting would serve as a sort of screen to a wooden statue of the Virgin and Child, which the members of the confraternity unveiled and worshipped once a year on the feast of the Immaculate Conception.[40] An extensive and detailed contract was drawn up and dated 25 April 1483.[41]

Lay confraternities were groups of people linked by a common profession or common devotion. They met and worshipped under the guidance of priests or monks and frequently endowed chapels for the purpose of common prayer.[42] The Immaculate Conception seems, from a modern distance,

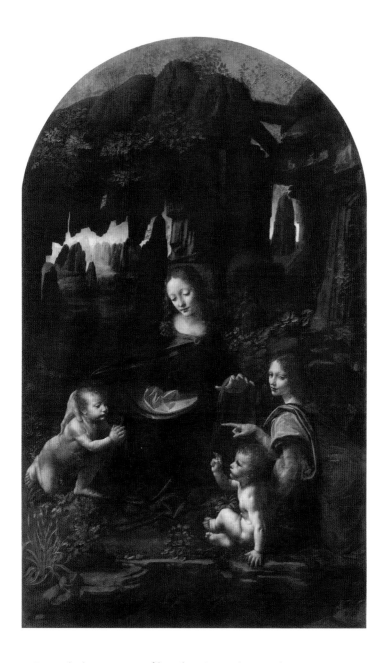

27 Leonardo da Vinci, *Virgin of the Rocks*, 1483–5, oil on panel.

a rather obscure theological doctrine according to which the Virgin Mary had been conceived free from original sin. The devotion to the Immaculate Conception is one of the most important and influential of the early modern era, but it could not be further from Leonardo's own interests. Nevertheless the commission gave him the opportunity to explore the theme of rock formations and delight in painting flowers with Marian associations. The subject of a Madonna accompanied by grottoes and rocks is not common, yet Christian interpretations have identified the grotto mentioned in the Song of Songs as a prefiguration of the Virgin.

We have seen Leonardo's ideas on religion and his particular annoyance with image worship. How, then, did he cope with the commission of an altarpiece that was to accompany a wooden medieval Virgin, the recipient of so much worship? By making the group of figures as distant as possible from the worshipper. For this purpose Leonardo went against a tendency of late medieval and Renaissance art to involve the viewer as much as possible in the image. Sometimes the perspective construction extends into the viewer's space or integrates portraits of donors into the pictorial space. Instead of connecting the space of the viewer with that of the painting, as Leonardo did by means of a parapet in his early Madonnas as well as in the portrait of *Lucrezia Crivelli* (see illus. 25), he emphasized the inaccessibility of the Virgin of the Rocks by a ravine that separates her from the viewer. The foreshortened right arm and hand of the Virgin who blesses the Christ Child enhances this impression of distance. Perhaps this uncomfortable and unusual positioning of the viewer, who is also the worshipper,

displeased the patrons and contributed to the rejection of the first version.

Apocryphal literature, including the anonymous *Life of John the Baptist*, reports that the meeting of the infant Christ and the Baptist occurred at the time of the flight into Egypt.[43] Yet the focus of this pyramidal composition of figures is didactic rather than narrative. The angel on the right points at John in prayer while Christ blesses him. The sum of these gestures assures the worshipper of the goodness and efficacy of prayer as well as of the intercessory role of the Virgin depicted blessing and protecting.

The rock formations, the grotto and the mountain are all mentioned in the contract for the entire altarpiece. The text even switches from Latin to vernacular language to provide a detailed list of the contents of the painting at the intention of the painters.[44] For the members of the confraternity, and the theologian monks who commissioned the chapel, the grotto and the mountains in the background symbolized Christ and the Virgin. Furthermore, the landscape possibly alludes to Francis of Assisi's last hermitage, the dramatic cliffs of the Monte de la Verna. The commission gave Leonardo the opportunity to paint rock formations he had already observed and drawn in Tuscany and to test his view that rocks and skin are contraries as far as their reception of shadows is concerned.[45] Yet in both versions of the *Virgin of the Rocks* the landscape on which the grotto opens, with its monolithic rock formations, is as imaginary as the grotto framing the main figures like a giant canopy. One source for this arrangement might be found in Leonardo's theatrical scene designs. One scene design in particular, of debated date, is a system in which the exterior

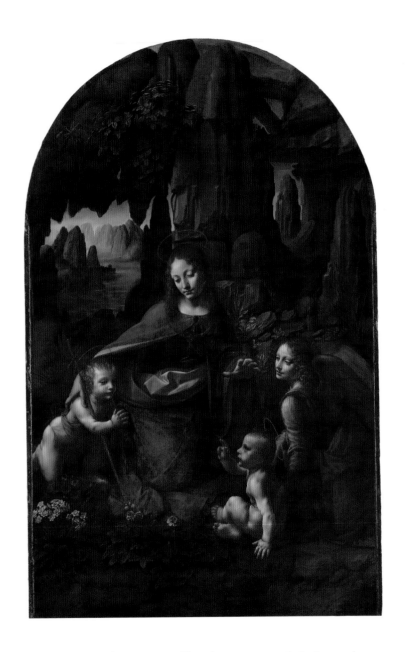

28 Leonardo da Vinci, *Virgin of the Rocks*, c. 1491–9, 1506–8, oil on poplar.

of a mountain opens in two halves, rolling out and back to form a cavernous interior (illus. 29).[46] Perhaps this contraption gave Leonardo the idea of the setting of the *Virgin of the Rocks*, or maybe he developed this idea from the picture to the theatrical stage. It does not really matter: the point here is that Leonardo's ideas were circulating across media, through all his activities.

It seems that Leonardo's personal interpretation of the subject caused the painting to be rejected by the confraternity. This gave rise to a long dispute, at the outset of which Leonardo produced a second version, completed only much later, in 1508 (illus. 28).

29 Leonardo da Vinci, 'Sketch for the production of Poliziano's *Orfeo*', in the Codex Arundel, *c.* 1508.

THE LAST SUPPER

The *Virgin of the Rocks* did not impact Leonardo's career, principally because it was removed from the public view shortly after its delivery. The next commission he received would, however, propel him to fame. Around 1492 Ludovico Sforza commissioned from Leonardo a mural painting of the Last Supper for the Milanese Dominican convent of Santa Maria delle Grazie (illus. 30). The Duke of Milan had a particular devotion to this monastery, and by financing its renovation he was also turning it into a monument glorifying his own dynasty.[47] The work was in progress in the first half of the 1490s and fully completed by early 1498.

Leonardo's experimentation with technique, as well as problems related to the dampness of the wall, which he could not anticipate, precipitated the deterioration of *The Last Supper*. The mural nevertheless remained in full splendour for quite a few years following its completion and brought Leonardo unprecedented fame.

Recent restoration campaigns have brought to light details smudged by earlier interventions, in particular the exquisite still-life on the 8-metre-long table. A great deal of the draperies have been lost, their folds echoing bodily movements which must surely have contributed to the symphony of emotion displayed in the mural.

Reproductions do not always tell us much about context. Here it is particularly important. *The Last Supper* decorates a monastic refectory. The perspective of the image extends that of the real room. In the refectory the monks would have dined in the same visual space as the Apostles depicted reacting

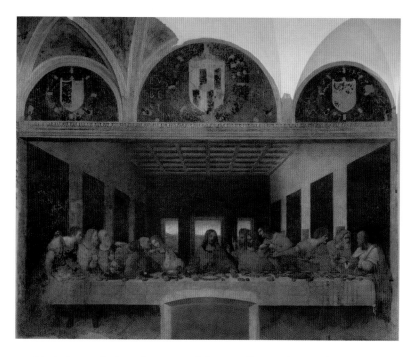

to Christ's revelation that one of them will soon betray him. Furthermore, facing *The Last Supper* and painted on the opposite wall by the Lombard painter Giovanni Donato da Montorfano (1460–1513), and completed in 1495, is a panoramic *Crucifixion* (illus. 31).[48] The painting does not include any liturgical symbolism – although in the Gospels the episode Leonardo depicted just precedes Christ's consecration of wine and bread as his body and blood (Matthew 26:14–29). The presence of a large *Crucifixion* facing *The Last Supper* nevertheless sets any potential meditation on the Eucharist in a narrative context: Christ is literally facing the events he foretells. Furthermore, all along the table, the arrangement of pieces of bread and glasses of wine again suggests the Eucharist. Thus although

30 Leonardo da Vinci, *The Last Supper*, 1495–8, oil and tempera on plaster, Santa Maria delle Grazie, Milan.

the picture contains all the elements necessary to prompt contemplation of the Eucharist, it illustrates the moment after Christ has foretold his death and announced to the Apostles that one of them will betray him.

Since much of the draperies have in large part flaked away, what remains focuses the expressivity of *The Last Supper* on faces

31 Donato da Montorfano, *Crucifixion*, 1495, fresco, Santa Maria delle Grazie, Milan.

and hands. It has been speculated that Leonardo used a musical canon of proportion for the entire composition.[49] While this has been contested on mathematical grounds,[50] the layout of the entire composition, and in particular the arrangement of windows and doors, is evocative of musical attributes such as rhythm and interval. Furthermore, the figures' hands and faces might be seen as like notes and chords on an imaginary stave or tablature. Be that as it may, Leonardo has prioritized the figures over the rest of the composition. Christ, at the centre of the perspective construction, is disproportionately bigger than the Apostles. The table is far too small for all of them to sit around. Such controlled disproportion is the outcome of Leonardo's emphasis on the Apostles' emotions, which he has distributed in four groups of three interacting figures. Seen in context, the contrast is particularly poignant and theatrical: while the Apostles argue in disbelief of Christ's announcement, he, and the viewer, sees in front of him his forthcoming agony on the cross.

The variety of emotions expressed by the Apostles, as well as the many studies left by Leonardo, testify to his sense of observation and confirm that, as he himself recommended, he spent much time observing human expressions in both public and private spaces. The figures on the left-hand side enact more subdued emotions than do the gesticulating groups on the right. To bring a further temporal dimension, Leonardo has depicted salt just spilled from a salt cellar by the side of Judas' arm. On the right the Apostles are far more agitated, as if they have had more time to react to the announcement of Christ's imminent betrayal and death. Perhaps their expressions are a reminiscence of those Leonardo observed

during the various courtly disputes and scholarly duels in which he participated.

If *The Last Supper* was a *tableau vivant*, acted by real people, not only would they not be able to all sit on one side of the table, but it would also be impossible for the spectator to see the food displayed on its top. Apart from the frieze of wine glasses, water carafes and loaves, the foodstuffs depicted have been identified as fish, mostly eel, served with orange slices and pomegranate (illus. 32). These do not bear any relationship to the traditional Passover meal mentioned in the Gospels but correspond to a typical northern Italian method of aromatizing fish.[51] It is very possible, as Goethe observed in the eighteenth century, that the food on the table had a similar origin and merely reflects the diet of the monastery.[52] The tablecloth too is based on traditional Lombard textiles of the time; thus the table of *The Last Supper* is a painted reflection of the real tables of the refectory.[53]

In spite of its modest culinary contents the table displays much pictorial skill in depicting a variety of optical phenomena, such as the reflection of light on metal or the transparent or translucent substances of glass, wine and water. The frontal presentation of the table might also be an echo of the table displays that graced most Renaissance banquets and with which Leonardo was undoubtedly familiar.

At the time of the preparation of *The Last Supper* the novella writer Matteo Bandello (1485–1561) was living as a novice at the monastery of Santa Maria delle Grazie. At the beginning of one of his stories, a brief digression recounts his memories of Leonardo's working on *The Last Supper*. This often quoted passage gives glimpses of Leonardo's method

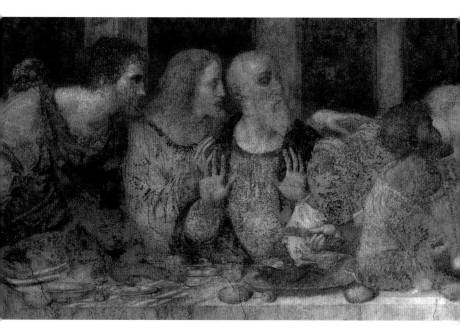

of self-observation which he discusses in his notes; it also
confirms the relative independence the artist was enjoying:

> Many a time I have seen Leonardo go early in the morn-
> ing to work on the scaffold before the Last Supper, and
> there he would stay from sunrise till darkness, never
> laying down his brush, but continuing to paint with-
> out eating or drinking. Then three or four days would
> pass without his touching the work, yet each day he
> would spend several hours examining it and criticizing
> the figures to himself. I have also seen him, when the
> fancy took him, leave the Corte Vecchia when he was
> at work on the stupendous horse of clay and go straight
> to [the monastery of] the Grazie. There, climbing on

32 Leonardo da Vinci, *The Last Supper*, detail of the left-hand side.

the platform, he would take a brush and give a few touches to one of the figures: and then suddenly he would leave and go elsewhere.[54]

The 'stupendous horse of clay' ('quel stupendo cavallo di terra') refers to the model of the Sforza equestrian monument, which occupied Leonardo during these years and greatly contributed to his rising fame.

THE SFORZA HORSE

The first evidence that Leonardo was working on the model of the horse is a letter of 22 July 1489 from the Florentine ambassador in Milan, Piero Alamanni, to Lorenzo de' Medici, reporting that Ludovico Sforza requires two masters able to cast Leonardo's model.[55] Il Moro was impressed by Leonardo's clay model but he had concerns about the feasibility of casting it in bronze, for one obvious reason: the Sforza horse was to be the largest bronze equestrian monument ever. The planned height of Leonardo's horse alone is estimated at about 7.2 m (23½ ft); with the rider the monument would have measured well over 8 m (26 ft) (illus. 33). The comparison with the most important equestrian sculptures of the time is illuminating: 3.2 m (10 ft 6 in.) for Donatello's *Gattamelata* (Padua), 4.25 m (13 ft 11 in.) for the Capitoline *Marcus Aurelius* (Rome) and 4 m (13 ft) for Verrocchio's equestrian *Colleoni* (Venice). The gigantic size of the Sforza horse would have required about 71 tons of bronze, which any mistake could have irremediably wasted.[56]

The clay model was exhibited in the centre of Milan on the occasion of the wedding of Ludovico's niece, Bianca Maria

33 Leonardo da Vinci, *Studies for Sforza Horse Monument*, *c.* 1489, black chalk on
paper washed buff.

Sforza, to Emperor Maximilian on 20 November 1493.[57]
Vasari writes that those who saw it report never to have seen
anything so beautiful and superb.[58] The event prompted poetic
praise. The verses of the official court poet Baldassare Taccone
(1461–1521) offer a fine sample:

> Look what [Il Moro] is having made in metal, a great
> colossus in memory of his father, and I firmly believe,
> and without doubt, that neither Greece nor Rome ever
> saw something as big. And look how beautiful is this
> horse, Leonardo da Vinci alone made it, sculptor, good
> painter and geometer, rarely such a mind comes from
> the sky.[59]

Indeed the statue was to be a colossus. According to
Pomponio Gaurico's contemporary treatise on sculpture
(1504), life-size statues were for sages and statesmen; up to
one and a half times life-size was for kings, emperors and
rulers; and up to twice life-size reserved for heroes and demi-
gods, such as Hercules or Bacchus. Three times life-size is the
dimension reserved for the gods, and just over four times
life-size the expected height of the Sforza monument!

Thus for Leonardo the Sforza horse was an opportunity
to establish himself as the greatest artist of his time, outdoing
not only his master Verrocchio and his predecessor Donatello,
but also the legendary sculptors of antiquity. For Ludovico
Sforza the equestrian colossus dedicated to the memory
of his father, Francesco, was a powerful assertion of his
dynasty as the rulers of Milan. Unfortunately, the project
never went beyond the stage of the model. Leonardo had

devised ingenious means of casting the horse in one piece,
but by 1494 the bronze initially earmarked for the monument
went instead to cast some of the artillery used to defeat the
French army of Charles VIII during the Battle of Fornovo in
1495.[60] The life-size model of the great horse spent its brief
life in the courtyard of the old palace, near the cathedral,
where Leonardo had his living quarters. In April 1499 the
French soldiers took over Milan and destroyed the clay horse.

34 Leonardo da Vinci, 'Casting Mould for the Head of the Sforza Horse',
c. 1491–3, red chalk, in Codex Madrid II (MS 8936).

This disaster contributed to Leonardo's growing reputation for never finishing what he started. Furthermore, while the size of the horse testifies to Ludovico's megalomania, the method invented by Leonardo to cast it also prompted criticism of his alleged hubris and foolish ambition. Leonardo wanted to cast the horse in one piece, a relatively easy procedure on small objects but a difficult and dangerous one on a large-size model (illus. 34). When preparing monumental works, Renaissance sculptors preferred to cast in multiple parts, which they would then assemble and weld, leaving seams visible only under close inspection – a method that survived well into the nineteenth century when, for example, the French government sent the Statue of Liberty to America. Thus one scholar has observed that the plan of casting the Sforza horse in one piece 'is therefore an aesthetic conceit which means more on the intellectual than the visual level'.[61] By planning to cast the horse in a single piece, Leonardo was cutting out several stages of manual work. The energy and thinking he invested in the preparation of this project stands out as a monumental attempt at art hiding art, a kind of monumental *sprezzatura*. Leonardo thus put plenty of energy and thought into making something extremely difficult, bold and dangerous look effortlessly made. Still, from the evidence left in his notes, Leonardo had some chance of succeeding at casting the great horse. A very similar and proven method illustrated in Denis Diderot's *Encyclopédie* confirms that his technical solutions survived.[62]

Leonardo's project for an equestrian monument never came to fruition. The Sforza horse was never cast and although the new French rulers of Milan also considered

commissioning an equestrian monument from Leonardo, this time to honour the *condottiere* Gian Giacomo Trivulzio (1440–1518), who fought on their side against the Sforzas, the project was eventually abandoned.

It is a sad irony that the bronze initially assigned to the Sforza horse monument went to use in cannon, as Leonardo realized at the time that the methods of casting heavy artillery could solve some of the problems he was grappling with. Renaissance Milan was the European capital of military weaponry, its workshops producing everything from the finest blades and suits of armour to the most powerful pieces of artillery.[63] While working on the Sforza horse Leonardo spent much time with the masters of these trades, furthered his understanding of casting and began devising improvements for various types of cannon. He also developed his interest in ballistics, while expanding his own thinking on the relation between energy, movement and weight.[64] By the time he left Milan in 1499, he had gained a thorough knowledge of military engineering. We also know that he frequented and regularly dined with the Milanese military elite. His familiarity with figures such as the *condottiere* Pietro Monte, Galeazzo da Sanseverino (Galéas de Saint-Séverin), Gentile Borri and Biagino Crivelli – all members of the close entourage of the Duke – confirm both Leonardo's keen interest and involvement in military matters and his remarkable social ascension.[65]

Sometime during his years in Milan Leonardo drafted a covering letter listing his skills and proposing his services to Ludovico Sforza.[66] He offered portable bridges and methods of digging tunnels to help armies cross waterways or to assault, destroy or protect any fortress or boat; designs for new

cannon, portable mortars that produced smoke, to cause great terror to the enemy, and never-before-seen armoured vehicles (illus. 35). Only the last of the ten sections of the letter mentions paintings or sculptures in any media, including the casting of the famous bronze horse. The date of the letter is debated: as it expresses Leonardo's wish to work on the bronze horse, it cannot have been written later than the late 1480s since Leonardo was already working on the horse in 1489. At the time of his arrival in Milan, in 1483, Leonardo could only have had moderate knowledge of artillery and military engineering; according to all contemporary sources, Lorenzo de' Medici sent him to Milan as a court painter, sculptor and musician, not as a military engineer. By the end of his stay, however, Leonardo had clearly gained impressive fluency in the arts of war. No document remains to confirm that the

35 Leonardo da Vinci, *Studies of Military Tank-like Machines*, c. 1485, pen and brown ink over stylus.

Sforza made use of his skills. Yet Leonardo's reputation must have been considerable, since a year after his departure from Milan he entered the service of Cesare Borgia as a military engineer. This period would have a formative impact on Leonardo's representations of war in texts, images and court festivities.

Florence to Milan, 1500–1513

ometime after August 1499 Leonardo summed up his Milanese years in one brief sentence: 'The Duke has lost his state, his possessions and his freedom, and none of the work for him was finished.'¹ While Leonardo was busying himself with research, painting, monumental sculpture, organizing festivities and inventing machines, his patron, Ludovico Sforza, was fighting for his life and would soon meet his downfall. He had initially allied himself with the French and encouraged King Charles VIII to assert his right to the throne of Naples – thus initiating the First Italian War. After seizing Naples the French turned north, and Ludovico, worried by their growing ambitions and the savagery of their soldiers, broke his alliance and joined the anti-French League involving Venice, the Pope, the Spanish and English kings as well as Emperor Maximilian. They gathered an army led by Francesco II Gonzaga, Marquis of Mantua. Ludovico provided soldiers and cannon – made from the metal initially assigned to Leonardo's horse. The French army was defeated at the Battle of Fornovo, near Parma, in 1495. This of course prompted French anger and ambitions on Ludovico's territories.

In August 1499 the French troops, now led by Louis XII, Charles VIII's successor, came back, invaded the Duchy of

Milan and massacred the inhabitants of the fortified towns of Rocca d'Arazzo and Annone on their way to Milan, which surrendered in September. In the meantime, Ludovico had fled and gathered an army. He briefly retook Milan from February to April 1500, when he was handed over to the French by the Swiss mercenaries he had initially hired. He spent the rest of his life in captivity in France, where he died in 1508.

After the fall of Milan to the French, Leonardo left for Venice and Mantua and eventually moved back to Florence in 1500. Before his departure he probably made contact with the new French masters of Milan and with Cesare Borgia, who entered Milan on the side of the French king. Some scholars have conjectured that Leonardo contributed to the festivities that accompanied Louis XII's triumphal entry into Milan on 6 October 1499. Leonardo was probably present and from this period onwards he cultivated cordial relations with the French rulers of Milan. He nevertheless left Milan for Venice in December and also spent some time in Mantua. He was back in Florence by April 1500, but rather than settling in his home town he seemed mostly intent on getting a new court appointment. From 1502 until the winter or spring of 1503, he worked for Cesare Borgia (illus. 36). Based in Florence again from 1503, he went back and forth between there and Milan, where he settled from 1508 to 1513 at the service of the French.

Leonardo had left Florence as an aspiring court artist and came back as the most famous artist of his time. The Leonardo of the Milan years was a perfect court artist and an accomplished courtier. Back in Florence, where the Republican

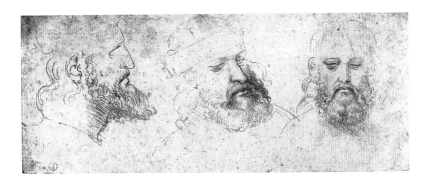

government had expelled the Medici in 1494, he was a celebrity. He could easily have set up a prosperous workshop in Florence, identified and trained a few talented assistants, and flooded the market with Madonnas and portraits in his distinct style. But he preferred to seek out another court appointment. In the meantime, he worked on a much smaller scale, preparing drawings from which his two assistants produced paintings, which he then retouched. Thanks to this delegating arrangement as well as his own savings he could devote more time to his own research in geometry and follow the independent and comfortable lifestyle that he strove for, as described in his notes on painting:

> the painter or draughtsman must remain solitary, and particularly when intent on those studies and reflections which will constantly rise up before his eye, giving materials to be well stored in the memory. While you are alone you are entirely your own [master] and if you have one companion you are but half your own . . . And if you have many companions you will fall deeper into the same trouble.[2]

36 Leonardo da Vinci, *Cesare Borgia*, c. 1502, red chalk.

THE ARTIST AT WAR

From about 1500, Leonardo collaborated intermittently with Cesare Borgia (1475–1507), the flamboyant ruler of Emilia-Romagna, made Duke of Valentinois by Louis XII, whose niece Charlotte d'Albret he married in 1499, and General of the Papal Armies by his father, Pope Alexander VI. On entering Milan with Louis in October 1499, Cesare saw *The Last Supper*, and he must also have heard of Leonardo's expertise as an architect and military engineer. He officially hired him sometime in 1502, for he refers to him as his 'familiar, architect and general engineer' in a document dated 18 May 1502.[3]

Shrewd, flamboyant, charismatic, ruthless and brutal, like a Mafia boss, Cesare Borgia was one of the models for Niccolò Machiavelli's *Prince* (1532). In a document dated 18 August 1502 Cesare conferred on Leonardo the title *Dilectissimo familiare* – literally 'a most appreciated member of his close entourage' – confirming that by then Leonardo's presence, conversation and advice were as sought after as his multiple skills.[4] During this intense period of territorial conquests Cesare had vital need of a military engineer, and not of a painter or sculptor. The period of Leonardo's employment corresponds to those intense times when Cesare's armies were conquering large parts of central Italy in the hope of establishing a territory that would last beyond the death of his ageing father.

A Latin poem by Francesco Perulo in praise of Cesare's campaigns mentions the foldable bridges Leonardo advertised in his letter to Ludovico Sforza, and so does his friend the mathematician Luca Pacioli.[5] These structures were ideal to ensure the prompt deployment of armies over natural

obstacles (illus. 37). Documents also confirm that Leonardo inspected fortifications. Most critically, he drew detailed maps thanks to which Cesare's captains could plan an efficient siege and plot successful assaults. Furthermore, the accounts of Cesare's winter campaign against Piombino include allusion to war machines which may have been produced or improved under Leonardo's supervision or following his plans, including explosive cannonballs (illus. 38).[6] His experience in bronze casting and his recent interest in ballistics had certainly made him aware of the potential use of the toxic and sometimes lethal properties of smoke. In his letter to Ludovico Sforza he speaks of portable cannon that would shoot explosive balls 'the smoke of which gives great horror, severe damages and confusion to the enemy'.[7] According to the historian Pascal Brioist, Leonardo's project of a movable assault tower was also built, but unsuccessfully.[8]

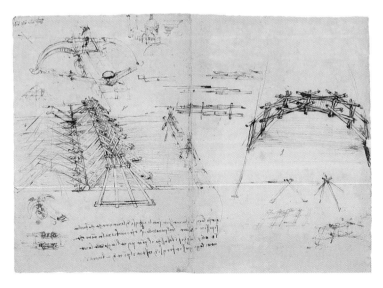

37 Leonardo da Vinci, *Foldable Bridges*, c. 1487–8(?), pen and ink, Codex Atlanticus fol. 55r/16v–a.

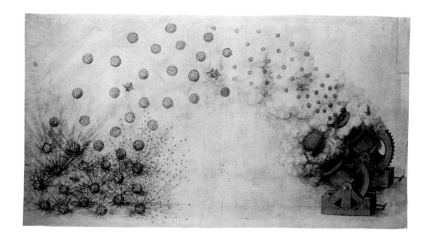

Most of the war machines and cannon Leonardo developed derive from earlier military treatises, in particular Roberto Valturio's *De re militari* (1472) and Giovanni Fontana's *Bellicorum instrumentorum liber* (c. 1420s). For instance, a terrifying chariot with scythes, which in peaceful times could serve as a harvesting machine or even a lawnmower, expands the custom of arming with scythes the wheels of chariot carrying artillery (illus. 40).[9] A standard theme in the scholarship on Leonardo's war machines is their impracticality. The armed vehicles carrying cannon (see illus. 35), for example, would be too heavy to move, too slow to recharge, and likely to produce enough smoke and heat to kill those inside. Leonardo himself conceded that some of his machines could be equally harmful to both sides.[10] There is no doubt, however, that serving Cesare Borgia left no room for mishaps, and that Leonardo contributed in important ways to his military successes.

The death of Pope Alexander VI on 18 August 1503, and the election of Julius II – from the Della Rovere family, sworn

38 Leonardo da Vinci, *Two Mortars with Explosive Shells*, c. 1495–9, pen and India ink, Codex Atlanticus fol. 33r/9v–a.

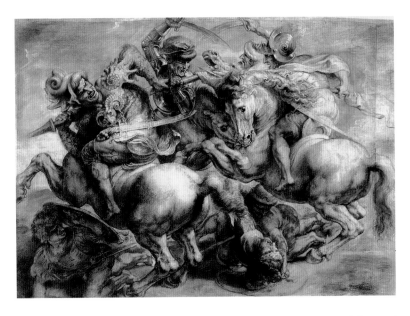

enemies of the Borgia – on 1 November precipitated the end of Cesare Borgia. Betrayed and captured in Naples, Cesare was transferred to Spain in 1504, where after several escape attempts he reached Navarra. There he became general of King John III's army and died in an ambush in Viana, in northern Spain, on 11 March 1507.

THE *BATTLE OF ANGHIARI* AND THE EXPERIENCE OF WAR

By March 1503 Leonardo was back in Florence. In July his name features in the account books of the painters' confraternity, a confirmation that he resumed painting. He was also involved in the war that Florence was waging against Pisa. In particular, he worked on the idea of diverting the river Arno

39 Peter Paul Rubens after Leonardo da Vinci, *The Fight for the Standard of the Battle of Anghiari*, c. 1603, black chalk, pen in brown ink.

through a system of canals that would deprive the Pisans of
their access to the river. The government adopted Leonardo's
plans but eventually abandoned the project through a mixture
of underfunding and poor management.[11] In November the
following year, Leonardo was sent to work on the fortifica-
tions of the Tuscan town of Piombino. The town had been
captured earlier by Cesare Borgia, partly thanks to Leonardo's
accurate maps, and returned after Cesare's fall to Jacopo
d'Appiani (1460–1510), the former ruler who distinguished
himself as a commander of the Florentine army.[12]

In these same years, war returned to the centre of Leo-
nardo's preoccupations as he took on the commission of the
Battle of Anghiari, a huge mural measuring 17.5 by 7 m (57 by 23
ft) (illus. 39). It was intended to commemorate the 1440
victory of the Florentine troops over the Milanese, led by the

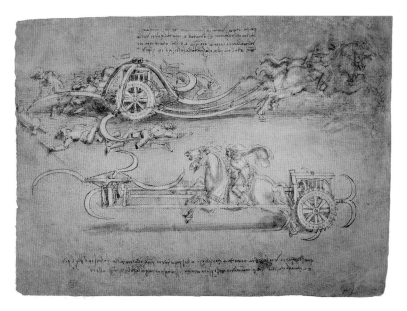

40 Leonardo da Vinci, *Scythed Chariot*, c. 1483–5, pen and ink.

condotierre Niccolò Piccinino and his son Francesco. In a typical spirit of competition and municipal pride the Florentine government assigned the other wall to Leonardo's new rival, the young and abrasive Michelangelo, with whom relations were less than cordial. Michelangelo was to depict the *Battle of Cascina*, fought by the Florentines against the Pisans in 1364 (illus. 41). He selected the moment when the Florentine soldiers, who were bathing in the Arno river, rushed out of the water to grab their clothing and equipment at the sound of the oncoming army. Michelangelo, like Leonardo, produced a cartoon, but left Florence for Rome, where he entered the service of Pope Julius II. His cartoon, however, was promptly reproduced in prints and became perhaps one of the most important and frequently copied repertoires of figures of the sixteenth century.

While the battle theme gave Michelangelo more opportunities to explore the male nude, Leonardo attempted the seemingly impossible task of rendering the forces deployed in a battle, in a continuum ranging from the effects of dust, smoke, light and blood to the detailed depiction of the expressions and movements of those fighting and dying.

A theme of war studies today is the difficulty of properly apprehending and accounting for the experiences of those who have fought in an armed conflict, particularly since many die or return with post-traumatic stress disorder.[13] The depiction of war was, however, well within reach of Leonardo's imagination, for not only did he witness armed conflicts at close range but he also knew and worked for the main actors of the wars that tore Renaissance Italy apart from the 1490s onwards.

Scholarship has emphasized Leonardo's interaction with the learned and erudite entourage of the rulers he served, but he was also acquainted with the Milanese military elite. After almost two years at the service of Cesare Borgia he had not only rubbed shoulders with anatomists, mathematicians and astronomers, but he also came back alive as the military engineer of the most demanding, aggressive and ruthless man of his time. While he served Cesare, he was in constant contact with his captains, whose success critically depended on the accuracy of his maps. He daily worked and interacted with these rough and brutal men used to the violence of the battlefield as much as to the ensuing pillaging, rapes and massacres characteristic of pre-modern warfare. Leonardo followed the army and witnessed battles and their savage aftermath inflicted on civilians. In October 1502 he was present at Fossombrone, a small village near Pesaro, which the papal soldiers sacked and burnt after slaughtering its inhabitants.[14]

Leonardo's acquaintance with military men gave him plenty of leisure to study them at close range, observing their manners and movements, and their muscular bodies, shaped by the handling of arms and horses and countlessly scarred with battle wounds. He also knew horses, the most important animals on the battlefield, very well. Leonardo was an experienced rider, keeping some horses for his own pleasure, and of course had studied horse anatomy extensively in his preparations for the Sforza monument. When he accepted the commission of the *Battle of Anghiari*, he was possibly the most experienced and best-prepared artist in the West to represent the war.

Work began on 24 October, when Leonardo received the key to the Sala del Papa in the monastery of Santa Maria

Novella, which he used as his workspace. There he prepared the cartoon of the mural, the outlines of which would eventually be transferred to the wall of the Palazzo Vecchio. Surviving documents include the contract and the evidence of payments as well as of the dissatisfaction of the Florentine authorities

caused by Leonardo's slow progress and his frequent visits to Milan.[15] We also know that Leonardo ordered enough cartoon to cover over 280 sq. m (3,000 sq. ft), about twice the area of the wall.[16] Before embarking on a work of such magnitude – the largest mural at the time – he would surely have shown

41 Aristotile da Sangallo after Michelangelo, *Battle of Cascina*, c. 1542, oil on panel.

a full clean sketch of the entire composition. All this is lost. Scholars have proposed reconstitutions of the entire composition, but the only traces of Leonardo's initial thoughts are a handful of small sketches (illus. 42) as well as some studies of expressions (illus. 43, 44). The visual remains of the *Battle of Anghiari* are four: two prints, a painted copy and an anonymous drawing, retouched by a contemporary of Leonardo and later by Peter Paul Rubens (see illus. 39). They all represent the fight for the standard.[17]

To contextualize these images further, we have Leonardo's own description of how to represent a battle. This text,

42 Leonardo da Vinci, *Study for the Battle of Anghiari*, 1503–4, pen and ink on paper.

normally dated by scholars to the 1490s, pre-dates by about ten years the commission of the *Battle of Anghiari*. Yet it testifies to the most important aspect of the projected mural: Leonardo's own visualization of war: 'First you must represent the smoke of artillery mingling in the air with the dust and tossed up by the movement of horses and the combatants.'[18] This passage introduces extensive considerations on the representation of the variations of light on dust in movement, which should be darker and denser at the bottom, finer and

43 Leonardo da Vinci, *Study for the Head of a Soldier for the Battle of Anghiari*, c. 1504–5, red chalk on ochre-pink prepared paper.

transparent at the top. The text progresses from these optical phenomena to the emergence of the human and animal forces at play. Leonardo imagines them in terms of *sfumato*, bringing the reader from bursts of dust and light to human silhouettes. As the descriptions reach the centre of the battle, Leonardo changes direction as he explains how to highlight 'the figures that are between you and the light [*le figure che sono infra te e il lume*]'.[19] From this point he describes the battle from the inside – a play on perspective where the person who perceives

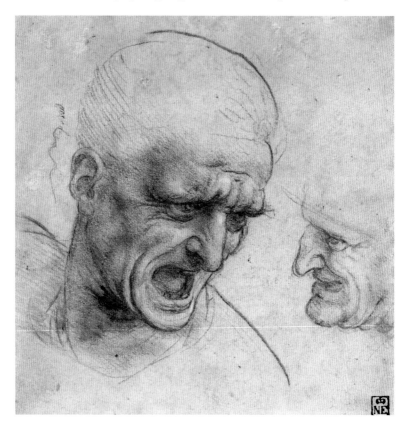

44 Leonardo da Vinci, *Study of Two Warriors' Heads for the Battle of Anghiari*, c. 1504–5, black chalk or charcoal, some traces of red chalk on paper.

eventually becomes the central point of the image. From this new angle Leonardo details the aspects, expressions and movements of the actors of the battle:

> You must make the conquered and beaten pale, their brows raised and knit, and the skin above their brows furrowed with pain, the sides of the nose with wrinkles going in an arch from the nostrils to the eyes, and make the nostrils drawn up which is the cause of the lines of which I speak, and the lips arched upwards and discovering the upper teeth; and the teeth apart as with crying out.[20]

This is followed by detailed advice on representing violent agony, from the expressions of the face to the convulsive movements of the body: 'Others must be represented in the agonies of death grinding their teeth, rolling their eyes, with their fists clenched against their bodies and their legs contorted.'[21]

Leonardo's imagination resembles his own pictorial style. There is indeed much *sfumato* in his visualization of war, from the varying colours of the smoke of artillery to the omnipresence of the dust, a natural medium of *sfumato*, a state in between smoke and matter through which corpses blend with the general picture:

> And you must make the dead partly or entirely covered with dust, which is changed into crimson mire where it has mingled with the flowing blood whose colour shows it issuing in a sinuous stream from the corpse.[22]

The only visual remnant of the *Battle of Anghiari*, the fight for the standard, displays a powerful concentration of animal and human energies as warriors and horses clash around the flagpole, which acts like a lever (see illus. 39). Leonardo sets the clashing energies and masses of the composition around the diagonal figure of the flagpole, with its centre of rotation on the left-hand side, enhanced by visual rhymes which only he could have thought of. The rider on the far right, identified as the Milanese Francesco Piccinino, wears an elaborate dress that has been identified as an allusion to Mars, the god of war.[23] Unlike the other riders, he wears typical Renaissance tournament gear rather than the more sober battlefield armour, and his figure is perhaps one of the most curved bodies in the history of painting. This unusual dress also allowed Leonardo, through this energetic curvature, to apply to human anatomy the naturally dynamic curves found in nature; these include the spirals of the ram's horn decorating the chest plate of Francesco's armour and the nautilus shell that Leonardo placed on his shoulder plate. Together with the emphatic curve of the torso, the organic spiral of his headdress and the pull of the flagpole around his arms, the Milanese is a human equivalent of the countless wheels and sprockets that Leonardo drew and projected for machines intended to mediate and transform energy.

The two soldiers on the ground are taken straight from Leonardo's earlier description:

And make someone shielding his terrified eyes with one hand, the palm towards the enemy, while the other rests on the ground to support his half raised body.

Some maimed warrior may be seen fallen to the earth, covering himself with his shield, while the enemy, bending over him, tries to deal him a death stroke.[24]

Unfortunately, as Leonardo writes,

on the 6th day of June 1505, Friday, at the stroke of the thirteenth hour I began to paint in the palace [Palazzo Vecchio]. At that moment the weather became bad, and the bell tolled calling the men to assemble. The cartoon ripped. The water spilled and the vessel containing it broke. And suddenly the weather became bad, and it rained so much that the waters were great. And the weather was dark as night.[25]

This was only the beginning of his troubles. For a variety of reasons that remain unclear, the medium and surface preparation with which Leonardo was experimenting did not dry as anticipated. At some point he lit a fire, hoping to accelerate drying; instead the painting began to melt and drip. His frequent visits to Milan further interrupted the pace of work until 1508, when Leonardo stayed on in Milan at the request of the French. Piero Soderini, then head of the Florentine government, could not afford to displease the French, whom he needed as military allies. Leonardo left behind the unfinished battle scene with its drippy remains, which Vasari and his teams whitewashed and repainted between 1555 and 1572.

LAST PAINTINGS

With the exception of the *St John the Baptist*, begun around 1513, Leonardo's last documented paintings date from the first decade of the sixteenth century.[26] However, he kept and continued to retouch his last three works – the *Mona Lisa*, the Louvre *St Anne* and the *St John the Baptist* – until his last days.

Scrutiny of his bank account has also suggested that he lived on his own means and enjoyed an independent lifestyle while looking for another court appointment, this time with the French rulers of Milan. The correspondence of Isabella d'Este's agent in Florence, Pietro da Novellara, confirms these impressions, providing glimpses of Leonardo's independent life. On 3 April 1501 he writes: 'as far as I can see, Leonardo's life is varied and undetermined, in such a way that he seems to live day by day . . . He has not done anything else [than an early, lost version of the *Burlington House Cartoon*] and his two assistants are producing paintings to which he puts his hand from time to time.'[27]

Shortly thereafter, Pietro da Novellara would meet Leonardo's assistant Salaì and some other members of his entourage ('alcuni altri suoi affezionati'), who make him understand that 'in a nutshell his mathematical experiments have distracted him so much from painting that he can hardly stand using a brush.'[28] Pietro further reports that Leonardo might be able to paint something for Isabella d'Este but that he is currently busy with the *Madonna of the Yarnwinder* for Florimond Robertet, the secretary and protégé of the King of France and currently based in Milan. In the end Leonardo produced only a drawing for Isabella, a portrait he did in

Mantua after his departure from Milan in late 1499 and which, as the fine pricking of the image outlines suggests, was probably used for a painting. Pleasing Robertet and the French in Milan was a much higher priority than responding positively to the Marchioness of Mantua, whose tyrannical behaviour with artists – Mantegna and Perugino in particular – was well known.[29]

LEDA AND THE SWAN

Leonardo's late works, the *Mona Lisa*, the *Madonna of the Yarn-winder*, the Louvre *St Anne* and the *Leda and the Swan*, all follow the format of figures set against landscape. They stand out as distillations of Leonardo's scientific interest and views on the similarities between nature and the human body. The *Leda* and the *Madonna of the Yarnwinder*, however, are known only through copies. The originals are either lost or never existed – this latter hypothesis strengthened by Pietro da Novellara's remarks that Leonardo produced cartoons from which his assistants would make paintings which he would merely correct and adjust.[30] In other words, these paintings would have been supervised and corrected by Leonardo, but not painted by his own hand.

The circumstances of the commission of Leonardo's *Leda* are unknown. Two versions of the painting survive. A so-called 'kneeling' *Leda* (illus. 45), attributed to Giampietrino (*fl.* 1495–1549) and kept in Kassel at the Gemäldegalerie, is based on a drawing by Leonardo held in Rotterdam (illus. 46); while the 'standing' *Leda* is known in at least four versions kept in Florence (Uffizi), Rome (Galleria Borghese; see illus. 48),

Salisbury (Wilton House) and Philadelphia (Johnson Collection).

Gods are too powerful for any mortal to behold. Thus each time the lustful Zeus wanted to unite himself with a mortal he took the shape of an animal. He became a swan to

45 Giampietrino, after a design by Leonardo, *Leda and Her Children*, c. 1520–40, oil (and tempera?) on alder.

possess Leda, the consort of Tyndareus, King of Sparta. From their union were born Castor and Pollux, Helen of Troy and Clytemnestra, the queen of Argos.

The flowers and vegetables depicted on the ground, the bulrush in particular, have oriented scholarly commentaries of the picture towards Leonardo's well-documented interests in botany and the reproductive forces of nature.[31] Comparing

46 Leonardo da Vinci, *Leda and the Swan*, c. 1504–6, black chalk, pen and brown ink.

Leonardo's interpretation of the theme of Leda with Michelangelo's later version (1530) (illus. 47) shows how little interested Leonardo was in sexuality. Michelangelo thought in terms of tangible sexual intercourse and Leonardo in terms of Platonic love. Thus while Michelangelo's version enhances the tactile engagement between Leda and the swan, Leonardo limited their intercourse to the two privileged sensory channels of Platonic love: sight and hearing (see Chapter One). In Michelangelo's version the swan's beak penetrates Leda's mouth, while his powerful wings caress her genitalia. In comparison Leonardo's version seems closer to camaraderie than to Zeus's restless sexuality. In the study kept in Rotterdam the swan touches Leda's ear with its beak (see illus. 46). The wing around her shoulder makes her look like an angel, while her hand around the neck of the swan suggests consent and harmony.

The best-known version of Leonardo's *Leda*, kept in Rome at the Galleria Borghese (illus. 48), enhances the sonic aspect of Platonic love. The swan's beak is shown open and its tongue points towards its palate, surrounded by a row of painstakingly painted white teeth (illus. 49). The swan is singing. Leonardo believed that swans could sing; his short treatise on anatomy states that the movement of the tongue, with the assistance of the teeth and palate, produces sound.[32] The imagined sound of Leonardo's swan is of course literary and relates to poetic evocations and scientific beliefs going back to the classics: Plato, Aristotle, Ovid and Virgil, this last sometimes nicknamed the Mantuan Swan. All these writers claimed that the swan has a beautiful and harmonious song, especially before it dies. Here we enter the same ideal universe as that

of the portrait of Cecilia Gallerani with the ermine. Real swans rarely sing, and when they do the sound they produce is best described as that of a baritone chicken.

Platonic love is also about sight. In contrast to Michelangelo's Leda, who is half covered by the assaulting swan, Leonardo's Leda is fully exposed to the viewer. Michelangelo's version focuses on genital stimulation and oral penetration, if not fellatio – the least Platonic aspects of love. Leonardo on the contrary does not emphasize any erogenous parts. Instead, indulging in the pleasures of the Platonic gaze, his interpretation proposes variations on the *figura serpentinata*, a typical Renaissance method of building a human figure and its movements around an S-shape that had already been introduced by Verrocchio in his *Putto with a Dolphin* (1470).[33] Very much as in the *Lady with the Ermine*, where the curves of the stoat echo those

47 Cornelis Bos after Michelangelo, *Leda and the Swan*, c. 1544–5, engraving.

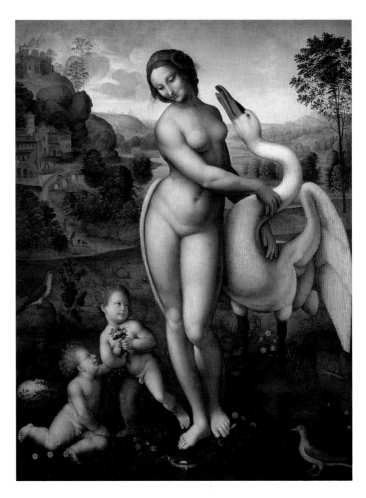

of Cecilia's hands, here Leda's S-shaped figure reverberates in the curves of the swan's neck. The swan's right wing embracing her lower body invites us to imagine her presence delimited by the tactile *sfumato* of the soft and warm, fluffy yet vibrant touch of the swan's wing. According to the Neoplatonic point of view, Leonardo's Leda would represent divine love,

48 After Leonardo da Vinci, *Leda and the Swan*, c. 1510–15, tempera on wood.

surrounded by the generative powers of nature, flowers and plants, which represent terrestrial love.[34]

The myth of Leda gave the most sought-after military engineer of his time the soothing possibility of representing, visualizing and mirroring a world harmoniously guided by celestial and terrestrial love. After experiencing war and its constant mental re-enactment in the long preparation of the *Battle of Anghiari*, Leonardo perhaps focused on these Platonic imaginations as a means of keeping his mental balance.

Although we do not know whether an autograph Leda ever existed, one extant drawing by Leonardo represents a study from the side and back of Leda's head and headdress (see illus. 46). These two views suggest that Leonardo was probably also thinking of this headdress as a wig for a theatrical performance. Here Leonardo returns to his love of intricate lines, creating tight plaited spirals and knot patterns on the

49 After Leonardo da Vinci, *Leda and the Swan*, detail.

back, very reminiscent of the filigree patterns of the *Salvatore Mundi*'s cloak.

All is connected in Leonardo's work: the Rotterdam drawing (see illus. 46) is not only the source of the *Leda*, it also served as the basis for the figure of the Virgin in the *Burlington House Cartoon* (illus. 51). The Virgin of the *Burlington Cartoon* in turn relates to the Louvre *St Anne* (see illus. 52) insofar as the latter is an inverted version of the former. In the same way

50 Leonardo da Vinci, *Leda Study of Headdress*, c. 1505–8, black chalk, pen and ink.

as Leonardo could write from right to left he could also paint and imagine in reverse, treating images in an ambidextrous way. His method of using a mirror to correct his paintings and drawings might have made him a virtuoso of inverting mental images.[35]

51 Leonardo da Vinci, *Burlington House Cartoon, c.* 1499–1500, charcoal (and wash?) heightened with white chalk on paper, mounted on canvas.

THE *ST ANNE* AND THE *BURLINGTON HOUSE CARTOON*

Leonardo's three main religious paintings of the period, the two versions of *St Anne* and the *Madonna of the Yarnwinder* (illus. 53), also deal with a problem specific to Leonardo's approach to connecting figures together.

As we have seen, his *Leda* expresses the ideal of Platonic love through the interconnection of two figures. In *The Virgin and Child with St Anne*, held in the Louvre (illus. 52), and the *Burlington House Cartoon* (*Virgin and Child with St Anne and St John the Baptist*) (see illus. 51), the figures of the Virgin and St Anne are also physically connected: one sits on the knee of the other. There are medieval precedents for the Virgin sitting on the knees of St Anne, but she is depicted as a child rather than an adult.[36] Leonardo's arrangement has surprised some commentators, such as Edward McCurdy, who wrote: 'There is some inevitable loss of dignity in the representation of a full grown woman seated in the lap of another.'[37] It is of course the magic of painting to make things strange seem natural, but women are rarely depicted sitting on the knees of one another. There is, however, one common instance in the Renaissance when one woman would sit on another's knees: childbirth. Until the obstetric revolution of the eighteenth century, midwives handled childbirth. The parturient woman would sit either on a birthing chair or on the open knees of the midwife, delivering in an upright position. Thus the position of the Virgin sitting on St Anne's knees could be merely evocative of childbirth and generation. This sense of postural allusion finds some confirmation in the *Burlington Cartoon*, where the graphic *sfumato* is such that the lower body of Christ gently blends with

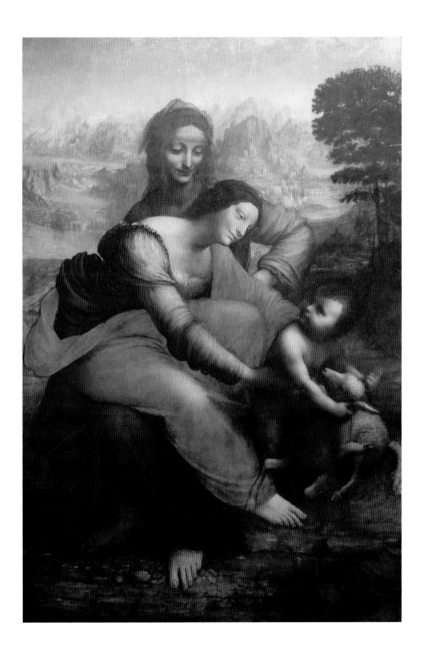

52 Leonardo da Vinci, *The Virgin and Child with St Anne*, c. 1505, oil on poplar.

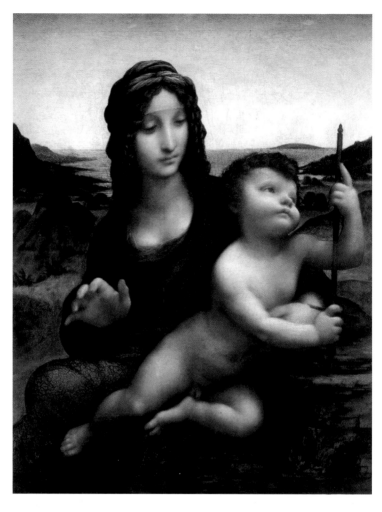

the belly of the Virgin, from which it bursts out in fluid lines, informed by Leonardo's studies of the movements of water, animals and children. Pietro da Novellara saw a lost cartoon by Leonardo on a similar theme, writing:

53 Leonardo da Vinci, *Madonna of the Yarnwinder*, c. 1501–5, oil on panel.

Since he came to Florence [Leonardo] has done . . .
one cartoon. It depicts the Christ Child of around a
year old who, almost leaving his mother's arms, takes
a lamb, and it seems as if he [wants to] clasp it. His
mother, half-rising from Saint Anne's lap, takes the
baby to take him away from the lamb (the sacrificial
animal) that signifies the Passion. Saint Anne, raising
herself from her seat a little, seems as if she wishes
to restrain her daughter so she would not separate
the baby from the lamb, which perhaps signifies that
the Church would not want to prevent the passion
of Christ.[38]

This theological interpretation is a precious document of
how a monk would interpret the *St Anne* and *Burlington Cartoon*;
it is, however, foreign to Leonardo's horizons and preoccu-
pations as they feature in his remaining notes. Yet Leonardo
contributed to the iconography of the Virgin and Child by
representing the Christ Child as escaping the embrace of
the Virgin to reach out to symbols of his destiny: a cross in
the *Madonna of the Yarnwinder* and a lamb in the *St Anne* and the
Burlington Cartoon. He reached this solution through natural-
istic means rather than theological speculation.

 The *Burlington Cartoon* (see illus. 51), the *Madonna of the
Yarnwinder* (see illus. 53) and the portrait of Cecilia Gallerani
(see illus. 24), as well as various Madonna and Child studies,
including the early sketch of a Madonna and jumping cat
(illus. 54), are all vivid variations on the theme of a woman
holding something that moves restlessly. Such restlessness,
which will be particularly familiar to owners of pet ferrets

54 Leonardo da Vinci, *Madonna and Child with a Cat, c.* 1478–81, pen and brown ink.

and stoats, raises the plausibility that Cecilia's unsuccessful attempt at keeping a real ermine quiet on her lap might have inspired Leonardo to transfer the restlessness of the food-driven little carnivore to the energy of a divine child literally animated by blind, pre-linguistic will to fulfil his destiny. This naturalistic approach fuses seamlessly with Pietro da Novellara's theological interpretation, for Leonardo's observation and representation of movements and emotions has reached sufficient depth and substance as to sustain and feed multiple layers of interpretation.

MONA LISA

Among the few masterpieces that can sustain endless layers of interpretation, adaptation and variation, the *Mona Lisa* is perhaps the most famous, most seen and most scrutinized (illus. 55). The *Mona Lisa* is not only a painting: it is a phenomenon, and probably the fullest accomplishment of the Renaissance obsession with re-creating life.

Before *Mona Lisa* became a myth it was a bourgeois portrait. The sitter is believed to be Lisa Gherardini (1479–1551), the wife of the Florentine silk merchant Francesco del Giocondo (1460–1539). It is not clear why Leonardo took on a portrait commission from a member of the urban middle class, to which he belonged via his father, while in the same period he was ignoring repeated requests from Isabella d'Este, one of the wealthiest art patrons of the time, for anything by his hand.[39] He had no financial problems, lived an independent lifestyle and made it known that he was too absorbed with geometry to devote time to painting. Scholars have

suggested personal links between Leonardo and the Del Giocondo family.[40] No written document confirming that Francesco del Giocondo formally commissioned a portrait of his wife survives. However, another testimony, a copy of the letters of the ancient orator Cicero annotated around 1506, confirms that by this time Leonardo was working on the portrait, of which he had only made the head.[41] Some portraits executed by Raphael around 1504–6 also confirm that he has seen the *Mona Lisa* at a stage before the landscape was begun.

Leonardo never delivered the portrait to the Giocondo family. He took it with him to Rome and then to France. When in October 1517 Antonio de' Beatis visited him with the Cardinal of Aragon in Amboise, he saw the *St John the Baptist* and the Louvre *St Anne*, but the first picture he mentions is 'one of a certain Florentine woman, a portrait at the request of the magnificent Giuliano de' Medici'.[42] Giuliano (1479–1516), who employed Leonardo from 1513 to 1516, could not have commissioned the portrait as he was exiled from Florence from 1494 to 1512. Perhaps he became fascinated, if not infatuated, by the portrait and asked Leonardo to finish it for him.

Leonardo was more interested in representation per se than in subjects. The mysterious *Mona Lisa*, as many scholars have observed, stands as the reciprocal embodiment of the human and natural world. According to Martin Kemp, for instance, 'the landscape portrays the earth as a living, changing organism, incessantly subject to the cycles of evaporation, precipitation, erosion and accretion.'[43] The mirror of this organism is the human body (illus. 56). A portrait became the starting point of a representation and meditation on

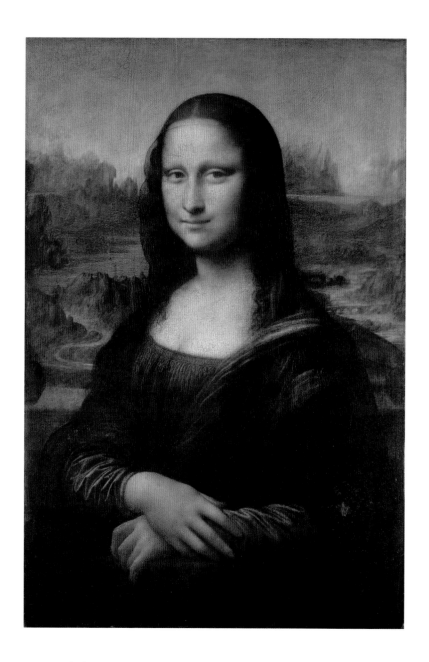

55 Leonardo da Vinci, *Mona Lisa*, c. 1503–19, oil on poplar.

56 Leonardo da Vinci, *Drawing of the Cardiovascular System and Principal Organs of a Woman*, c. 1509–10, black and red chalk, ink, yellow wash, finely pricked through.

the similitude between the human body and nature, which Leonardo described in the following words:

> In as much as man is composed of earth, water, air and fire, his body resembles that of the earth; and as man has in him bones the supports and framework of his flesh, the world has its rocks the supports of the earth; as man has in him a pool of blood in which the lungs rise and fall in breathing, so the body of the earth has its ocean tide which likewise rises and falls every six hours, as if the world breathed; as in that pool of blood veins have their origin, which ramify all over the human body, so likewise the ocean sea fills the body of the earth with infinite springs of water. The body of the earth lacks sinews, and this is because the sinews are made expressly for movements and, the world being perpetually stable, no movement takes place, and no movement taking place, muscles are not necessary. But in all other points they are much alike.[44]

The possibility that the *Mona Lisa* might be pregnant, that it is a mother figure as well as a mother nature, is just one more likely layer of interpretation absorbed by the intensity of the image.[45] To achieve this effect of presence and enhance the relation between the figure and the landscape, the curves of the drapery and body of the sitter echo the sinuous landscape of trails and rivers in the background. Leonardo has again made use of a familiar accessory of portrait and devotional painting: the parapet. Instead of placing a parapet between the viewer and the sitter, as he did in his early Madonnas, he

placed it behind Lisa. This arrangement tends to push the sitter outside the picture, while the arm of her chair acts as a second parapet, on which she rests her hands, oriented towards the viewer.

THE *SALVATOR MUNDI*

While Leonardo was working on the most famous painting in the world, he was also preparing the most expensive painting in the world. From this period also dates the *Salvator Mundi* (illus. 57), which on 15 November 2017 fetched at auction the astronomical sum of more than $450 million. It is certainly a workshop painting: Leonardo's intervention is evident on the blessing hand and the hair locks.[46] The rest may well be the supervised work of an assistant and would further confirm Pietro da Novellara's observation that Leonardo prepared cartoons from which his assistants produced paintings which he later retouched. In this case Leonardo himself would also have painted the inside drapery and its ornamental stripe, while entrusting the outer part of Christ's cloak to an assistant. The filigree pattern on the outside of the dress, in particular, is noticeably flat, in contrast to Leonardo's treatment of similar graphic motifs in the portrait of Cecilia Gallerani, in the *Mona Lisa* and in the *Leda* headdress. In the *Salvator Mundi*, the contours of the ornamental stripes inside the cloak curve around Christ's chest and gently ripple with delicate shadows, echoing the folds of the drapery. The outside stripe, however, looks like stiff geometric pipework (illus. 58). The contrast between the two stripes is one between a style with *sprezzatura* and a 'wooden' style – that is, between Leonardo's confident

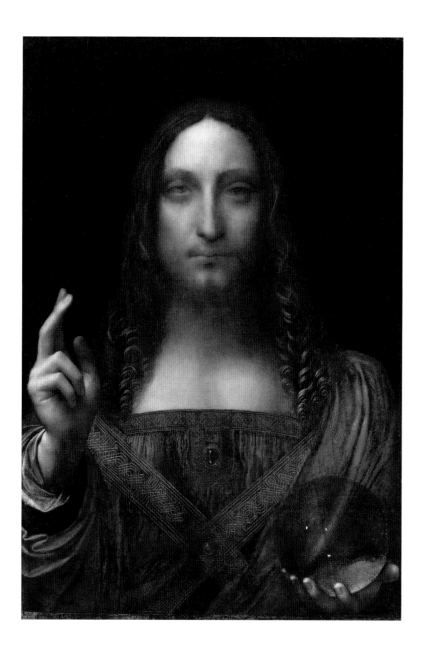

57 Leonardo da Vinci, *Salvator Mundi*, c. 1500, oil on walnut.

and experienced hand and that of a zealous but not yet fluent workshop assistant.

Some scholars have also pointed out that the *Salvator Mundi* does not resemble any other known Leonardo painting. Indeed, the figure of Christ is unusually frontal, positioned completely parallel to the picture plane, in striking contrast to Leonardo's tendency to orient the lower body, torso, limbs and head at different angles in relation to the plane, and never to represent the face with the frontal aspect of a passport photo. This image of Christ, however, is standard in fifteenth-century Flemish devotional painting and harks back to Byzantine art. Leonardo probably saw images in the style of Hans Memling's *Christ* (1478) (illus. 59). Thanks to the commercial links between Florence and Flanders, and the Medici collections, Leonardo knew Flemish art, from which he had adopted and adapted the oil medium. Here the patron might have

58 Leonardo da Vinci, *Salvator Mundi*, detail.

influenced his choice of iconography. Leonardo painted the *Salvator Mundi* for the French king Louis XII, from whom he was hoping for some patronage, and thus his choice of depicting a northern European iconographic type in Renaissance style might reflect his perception of French taste of the period.

59 Hans Memling, *Christ Giving His Blessing*, 1478, oil on oak panel.

Leonardo's approaches to the French were successful. From 1506 he travelled intermittently to Milan, where he remained from 1508 to 1513 at the service of the French governors with the title of 'peintre et ingenieur ordinaire'.[47] He directed and delivered the second version of the *Virgin of the Rocks* (see illus. 28), organized banquets, feasts and triumphal entries, and continued to work on military matters; he produced maps of strategic importance for the French army, projected canals and studied ballistics.[48] Soon, however, events would force him to leave Milan again.

The Final Years: Rome and Amboise, 1513–19

hile Leonardo was spending pleasant and productive days working for and dining with French high society, the Sforza were marching back to Milan. On 29 December 1512 Massimiliano and Cesare Sforza, the sons of Ludovico Sforza, who had died in exile in 1508, reconquered Milan from the French. Although Leonardo remained in Lombardy, he did not resume work with the Sforza, his former masters. He stayed near the village of Vaprio, by the Adda river, about 20 km (12 mi.) northeast of Milan, at the villa of the Melzi family, whose young son Francesco (1491–1570) had become his devoted pupil.[1]

In the meantime things were looking good for the Medici, especially the two sons of Lorenzo il Magnifico, Leonardo's first patron. Thanks to the Holy League of 1511, the political alliance organized by Pope Julius II that expelled the French from Milan, the Florentine Republic lost its French allies and the Medici came back to take power in Florence in 1512. In March 1513 cardinal Giovanni di Lorenzo de' Medici (1475–1521) became Pope Leo X. He made his brother, Giuliano, general of the papal army, a function previously held by Cesare Borgia. Leonardo was invited to join the suite of Giuliano on account of his engineering skills and military

experience as well as his long-standing relation with the Medici. On 23 September 1513 Leonardo left Lombardy for Rome, accompanied by three assistants.[2]

Leonardo lodged at the Vatican, in the Belvedere Palace, with the suite of Giuliano de' Medici. Vasari reports that he spent his time doing strange experiments. One involved inflating animal intestines until they would fill an entire room.[3] The only documents related to this period are two letters to Giuliano complaining about the misdemeanours of a German workshop assistant.[4] These letters confirm that Leonardo is working on parabolic – or concave – mirrors and is mostly interested in their burning properties. He read in Plutarch and Lucian how the Greek engineer and mathematician Archimedes used the power of such mirrors to concentrate solar energy and reflect back burning beams that set the Roman fleet alight in Syracuse harbour.[5] Aside from these military matters Leonardo received the task of draining the marshes north of Rome through a system of canals; he also drew maps, and advised on the consolidation of fortifications in the harbour town of Civitavecchia.

Giuliano's death on 17 March 1516 interrupted these projects and left Leonardo without a patron. Leo X, Lorenzo de' Medici's other son, seemingly had no interest in keeping Leonardo employed in Rome. Renaissance popes traditionally brought artists from their own province to leave their mark on Rome. Thus many of Leonardo's contemporaries and younger rivals had been called to Rome and given major commissions. At the time, Michelangelo and Raphael dominated the Roman artistic scene. Michelangelo had recently painted the Sistine Chapel ceiling (1508–12), and in 1513,

when Leonardo arrived in Rome, Raphael was working on the Vatican *Stanze* and had just completed the decoration of the Villa Farnesina (1510).

Strangely enough, Leonardo, one of the greatest artists of his time, was actually excluded from the great building site of the High Renaissance that was early sixteenth-century Rome. He received no notable painting commissions, probably because by the 1510s he had acquired a poor reputation as an artist and had more or less stopped painting to focus on military and hydraulic engineering. Many of his artistic projects had either ended in disaster or been left unfinished. *The Last Supper* was deteriorating, the *Adoration of the Magi*, the *St Jerome* and the *Battle of Anghiari* were abandoned and the colossal horse monument never took shape. These misfortunes, together with Leonardo's growing lack of interest in producing paintings, had permanently dissuaded potential patrons from commissioning large-scale works from him. Vasari reports that Pope Leo X asked him to produce a small panel painting but expressed annoyance when he found out that Leonardo had not yet begun the piece and instead was already working on the preparation of the varnish.

Thus in 1516, at the age of 64 – a very advanced age by early modern standards – Leonardo found himself without a patron. Scholars have conjectured that his bitter note 'The Medici created and destroyed me' dates from this period.[6] Bitter or not with the Medici, Leonardo was still very much sought after, especially by the French, with whom he had solidified cordial relationships during his second stay in Milan. On 18 March 1516, just one day after the death of Giuliano de' Medici, the royal counsellor Gouffier de Bonnivet wrote

from Lyon to the French ambassador in Rome, Antonio Maria Pallavicini, to ask him to invite Leonardo to France.[7]

By the following winter Leonardo was on his way to France to take up a generously remunerated appointment as 'paintre du Roy' for the French king Francis I. He received a pension of 1,000 livres, a fortune at the time, and lodged with his assistants, Salaì and Francesco Melzi, in a small castle, the Clos-Lucé in Cloux, connected by a tunnel to the royal residence of Amboise. In a brief note he referred to his new abode as a palace.[8] He died there on 2 May 1519. It is now a Leonardo da Vinci Museum.

Although Leonardo's title was 'paintre du Roy', he does not seem to have painted much during these last years. Instead he worked on a system of canals, architecture, town planning and court festivities.[9] Antonio de' Beatis, the secretary of the Cardinal of Aragon, visited him in 1517. He saw the *St John the Baptist*, the Louvre *St Anne* and probably the *Mona Lisa*. He reported that a paralysis of the right hand meant that nothing good in terms of painting could be expected from Leonardo anymore – apparently unaware that Leonardo was ambidextrous and painted and drew with his left hand. He added:

> He has his well-trained Milanese assistant who works very well, and although Leonardo cannot paint [*colorire*] with the sweetness with which he used to, he still produces drawings and teaches others.[10]

These remarks suggest that, just as in Florence, Leonardo merely produced cartoons and supervised his assistants in the

painting process while attending to other business. Apart from a *St John the Baptist in the Desert*, known only through copies and which was later transformed into a Bacchus (illus. 60), we do not know of any other painting he might have made for Francis.[11] Leonardo's involvement in several court festivities hints at the production of drawings. The *Feast of Paradise* (1517) and the reconstitution of the *Battle of Marignan* (1518), in which Francis I wears arms painted by Leonardo himself, alas lost, offered considerable scope for ephemeral images, emblems and allegories, as well as for experimentation and the display of ingenious machines, elaborate clothing, ornate helmets and suits of armour, banners, and banqueting extravaganzas.

Several documents confirm that throughout his life Leonardo orchestrated or participated in the organization of the many festivities, banquets, tournaments and theatrical representations that punctuated the intense and agitated lives of his aristocratic patrons. Only some drawings remain, suggesting, in light of Leonardo's documented activities, that much has been lost. The earliest date from his youth; others from his last years.

Already as an apprentice in Florence Leonardo assisted Verrocchio in preparing banners for tournaments and produced designs of helmets, of which the British Museum drawing is a typical example (see illus. 61). The introduction of artillery fire on the battlefield had made suits of armour irrelevant as combat gear, but they survived in the sixteenth century as elaborate metal outfits worn on festive and official occasions. Milan, where Leonardo spent a third of his life, was reputed for its dynasties of armour-smiths, the Negroli and

60 Leonardo da Vinci, *Bacchus*, or *St John the Baptist*, 1510–15, oil on panel mounted on canvas.

the Missaglia in particular, who produced some of the finest parade and tournament wear of the time.[12]

Renaissance artists and armour-smiths reinvented rather than copied antique suits of armour, combining classical designs with elements borrowed from the imaginary worlds of mythology and chivalric romances. Parade helmets based on the ancient Roman type served as the starting point of countless variations. Accounts of Renaissance tournaments mention golden helmets with peacock feathers and emblematic animals: lions, ermines, dragons, salamanders on a bed of gilded flames, or hybrids with reptilian skin, bat wings and the head of an eagle. Some helmets displayed shining images of mythological tutelary figures, such as Mars or Minerva.[13] Leonardo's version, with dragon wings and floral motifs, combines ornamental plays on antique patterns with elements of bird anatomy (illus. 61). It was probably with this festive genre in mind that he suggested a combinatory method to create imaginary animals:

> if you wish to make an animal, imagined by you, appear natural – let us say a Dragon – take for its head that of a mastiff or a hound, with the eyes of a cat, the ears of a porcupine, the nose of a greyhound, the brow of a lion, the temples of an old cock, the neck of a water tortoise.[14]

Such headdresses were worn at official and festive events, pageants and tournaments where participants would parade clad as antique heroes, with their horses, staff and banners decorated with emblematic devices. Leonardo almost certainly

designed and painted himself some of Francis I's tournament gear.[15] We know that he also designed some theatrical costumes (illus. 62). Some of Leonardo's notes also provide brief directions on how to make a carnival outfit with scented varnish and knot-pattern decorations.[16] In France he might have designed more emblems and *imprese*, or perhaps amused himself by inventing more costumes.

Leonardo also used festivals as a platform to display his mastery of machines. One such invention, which in his day followed his fame as a painter, is the mechanical lion that he used on several occasions. Reports of the earlier versions of the lion, the most famous by Vasari, refer to the 1509 entry of Louis XII into Milan: 'During [Leonardo's] time in Milan, the King of France came; because he asked Leonardo to make something eccentric [*bizzarra*], he made a lion that walked a few steps, then opened his chest and showed that it was full of lilies.'[17] The mechanical lion also featured twice as a diplomatic welcome to the visiting French king Francis I in Bologna in 1515, as well as in Lyon, from the Florentine expats. The ageing mechanical lion must have travelled with Leonardo's luggage to France, as it reappears during the French court festival of Argentan in October 1517. A letter from the Mantuan ambassador Rinaldo Ariosto relates the various military games played by the king and his entourage on this occasion.[18] In one such game, the king and his companions fight four wandering knights in a tournament. After this staged victory a hermit gives the king a magic wand and begs him to kill a lion that is ravaging the country. Brought to the lion, the king hits it three times with his wand, 'and this same lion then opened itself, and inside he was all blue, which in this country means love'.[19]

Another report is more explicit and adds: 'It all opened, the colour inside was blue, with a lily in the middle.'[20]

In May 1518 Amboise was celebrating the baptism of Francis III, Dauphin of France (1518–1536), as well as the wedding of Lorenzo de' Medici, Duke of Urbino (1492–1519)

61 Leonardo da Vinci, *Warrior in Tournament Armour*, 1475–80, silverpoint on cream prepared paper.

62 Leonardo da Vinci, *A Masquerader on Horseback*, *c.* 1517–18, black chalk, pen and ink and wash on rough paper.

and Madeleine de La Tour d'Auvergne (1498–1519), Francis I's niece. This event brought about seven days of feasting, banquets, tournaments and military plays. These were re-enacted in 2015 thanks to a collaboration between the Clos-Lucé, Leonardo's last residence, and the Centre d'Études Supérieures de la Renaissance in Tours.[21]

The peak of the celebration was a re-enactment of the 1515 French victory at Marignan played by the French king himself and his entourage, all dressed in elaborate tournament gear. Leonardo is believed to have orchestrated the event. To stage the final assault of the first day, he had his assistants paint the facade of a fortress, as well as fortified walls, on large pieces of canvas. The account of the fight by the Mantuan ambassador Stazio Gado clarifies one purpose of Leonardo's experimentations with inflating animal guts, mentioned earlier. Gado speaks of artillery fire and smoke out of which giant balloons would emerge, hitting the fortress and falling to the ground and bouncing back, to the delight of the audience.[22] Since no balloon would withstand the shock of mortar fire, Leonardo probably made use of artificial smoke. In a spirit typical of Leonardo studies, the machine he might have devised to throw inflated balloons against the painted fortress has been rebuilt as a sort of mechanical slingshot.[23]

SFUMATO AND THE ARTS OF SMOKE

As 'paintre du roy', Leonardo probably had a hand in the triumphal arch with emblematic images that featured in the Medici wedding, opening the May 1518 festivities.[24] Antonio de Beatis, who visited him in 1517, saw the three paintings

Leonardo brought with him from Italy and on which he was still working: the *Mona Lisa*, the *St John the Baptist* and the *St Anne*. At a basic level these three works are samples of what Leonardo and his assistants were able to produce: outstanding portraits that seem alive; small pictures for private devotion in *sfumato*; and religious images of interacting figures for altarpieces. Since Leonardo kept on occasionally retouching them, they probably share the same paint and were shaped by the same brushes.

Leonardo's work has been studied intensely by generations of scholars, so each of these three pictures comes with a considerable intellectual baggage that turns the temporary assemblage of their presence, in Leonardo's castle, into a powerful iconographic programme summing up his life and work. The *St Anne* is about human generation, the movements of the body and the soul. The *Mona Lisa* is expressive of Leonardo's intuition and exploration of the similitude between the human body and the natural world. Finally, the *St John*, as a thorough demonstration of *sfumato*, synthesizes Leonardo's lifelong interest in light and shadow (illus. 63).

Begun around 1513, the *St John the Baptist* is Leonardo's last known painting. An anatomical study of the movements of the head, shoulder and neck dating from the same years (see illus. 13) confirms that Leonardo was interested in the muscles involved in bodily positions and movements similar to those he depicted in his *St John the Baptist*. The fur and the cross are unmistakable attributes of the Baptist, but the figure also connects to a drawing study of an angel of the Annunciation – a character often represented with a finger pointing upward.[25] The motif of a figure with a raised arm features also

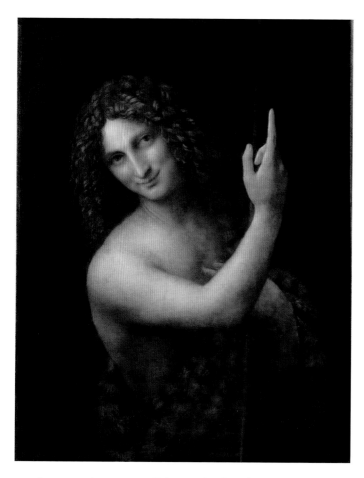

on the central warrior of the 'Fight for the Standard', with considerable expressive variations, and a tight fist substituted for a pointed finger (see illus. 39).

For Leonardo the first meaning of the *Baptist* is Florence: St John is the patron of Florence and his image would have stood as a national banner of Leonardo's Florentine identity. The androgynous character of Leonardo's *Baptist* has also

63 Leonardo da Vinci, *St John the Baptist*, c. 1513, oil on panel.

prompted speculations on his male-oriented sexuality.[26] It is indeed an unusually sensuous work, far more than his female portraits or than his Platonic *Leda*. The picture has also been understood as an illustration of the first verses of the Gospel of John, which describe the coming of Christ as the coming of light and John the Baptist as the one who 'came to bear witness to the light' (1:6).[27]

The hand gesture which St John makes in the painting is somewhat ambiguous, however, as it points beyond the limits of the painted surface rather than at the cross itself, which Leonardo has left in darkness. It is so because light, not the cross, is the subject of the painting. Leonardo's most intense display of *sfumato* reaches its climax in the depth and relief of the pointing hand. The pointing hand is pointing at itself, as a palette of the gradations of light and dark, shadows and transparencies, as a witness of Leonardo's lifelong study of light and shade.

Leonardo's style was influential in northern Italy, not only through his former assistants Giovanni Antonio Boltraffio (1467–1516), Bernardino Luini (*c.* 1482–1532) and Andrea Solari (1460–1524) – the so-called Leonardisti – but through mainstream Venetian artists such as Giovanni Bellini (1430–1516), Giorgione (1478–1510) and Titian (1488–1576), who also adopted, developed and integrated Leonardo's *sfumato* into their own pictorial vocabularies. By the 1550s the first art historian, Vasari, had declared Leonardo the herald of the modern style and embedded his life and work in his grand narrative of the history of art.

According to Vasari, from the thirteenth century onwards Tuscan artists abandoned the stiff and flat manner associated

with Byzantine art. This revolution in the representation of the human body began with Cimabue (1240–1302) and Giotto (1267–1337), who introduced volume and expression in painting. It followed a style characterized by dry graphic outlines and brittle drapery folds, which Vasari associated with fifteenth-century art and which were superseded in the sixteenth century by

> the works of Leonardo da Vinci, who, giving a beginning to that third manner which we propose to call the modern – besides the force and boldness of his drawing, and the extreme subtlety wherewith he counterfeited all the minuteness of nature exactly as they are – with good rule, better order, right proportion, perfect drawing, and divine grace, abounding in resources and having a most profound knowledge of art, may be truly said to have endowed his figures with motion and breath.[28]

The view that Leonardo was interested in painting itself, independent of the subjects he had to depict, is a common thread in Leonardo studies from the twentieth century to the present.[29] When Leonardo wrote that the purpose of painting is to make something flat stand and look in relief, he emphasized a specificity of painting independent of iconography. Indeed he had only moderate interest in the religious themes he was paid to depict and used commissions as means to explore the only subject he was really interested in: nature. His notes on painting are particularly revealing in this matter. Leonardo provides guidance for representing three subjects

particularly close to his pictorial interests: war, floods, and night scenes which involve a deployment of *sfumato*.[30] This is in sharp contrast to later artists and art historians such as Giovanni Battista Armenini (1530–1609) or Gian Paolo Lomazzo (1538–1592), who provided guidance on routine subjects: the Madonna and Child, the Last Supper, the Crucifixion, the Resurrection and so on.[31] As the first painter-aristocrat, Leonardo thought of painting and drawing as means to acquire, represent, examine and transmit knowledge, rather than as ends in themselves or as means to generate income.

Following Aristotle, Leonardo once wrote that there is nothing in the intellect that was not previously in the senses.[32] To this could be added that there is nothing in Leonardo's work that was not previously in nature (including, of course, the material of painting). The *sfumato* is a case in point. By means of multiple transparent layers of thin colours Leonardo created an illusion of relief. Though this has been treated as a distillation of his studies on optics,[33] *sfumato* is not only optical; its sources and ramifications are multiple.

First, the metaphorical potential of the concept is spectacular. The idea of blurring contours and blending with the environment can be, for instance, understood beyond optics as evocative of a permanent state of porosity within the world. *Sfumato* would be an expression of what came to be described in the twentieth century as the porous self, a state of connection with the world characteristic of the pre-modern lack of distinction between subject and object.[34] *Sfumato* can also serve modern views on the extension of the soul in the world. Its range between the extremes of light and darkness also lends itself to theological speculations and has even generated the

hypothesis that Leonardo invented this technique to represent the Immaculate Conception.[35]

Second: matter. *Sfumato*, as its etymology indicates, comes from *fumo*, smoke, and relates to Leonardo's considerable experience and manipulation of smoke. Smoke was always present in his life. For him it was an intermediary state of matter, between dust and air. His first contact with smoke might have been in the chimney of the farmhouse where he spent his childhood, but it is surely with Verrocchio, with whom he learned the arts of sculpting with fire, that he became familiar with the properties of smoke. In his notes on painting he observed the differences in colour and texture of the smokes of dry woods.[36] In one experiment he burnt some wood and watched its smoke rise against a black velvet background to establish its exact blueness.[37] In fact, smoke is for him a source of colour, if not itself a colour, yet the words he uses to describe colour do not only refer to optical entities: 'the sky looks darkest overhead and towards the horizon it is not blue but rather between smoke and powder (*fumo e polvere*).'[38] He used the smoke produced by candles to darken paper.[39] He seems also to have made much use of smoke on the battlefield, not only in his evocation of battles, beginning with the smoke of artillery, but also, as we have seen, he invented cannonballs expected to explode with 'a smoke that brings terror and damages to the enemy'. In another passage he thinks of narcotic smokes,[40] and elsewhere of a German method to fume a garrison, to which he adds his own recipes:

The Germans are wont to annoy a garrison with the smoke of feathers, sulphur and realgar [a toxic

sulphide of arsenic], and they make this smoke last
7 or 8 hours. Likewise the husks of wheat make a
great and lasting smoke; and also dry dung; but this
must be mixed with olive husks, that is, olives pressed
for oil and from which the oil has been extracted.[41]

64 Leonardo da Vinci, *Ginevra de' Benci* (illus. 10), detail of curls.

In his last years, the reconstitution of the military victory of Marignan gave him another opportunity to display his mastery of machines and costume design – but also of smoke. The re-enactments of battles and assaults he orchestrated involved much artillery fire and therefore required the controlled use of artificial smoke, through which he enhanced his live representations of war.

Sfumato as light and shade is the subject of Leonardo's last painting, the *St John the Baptist*. *Sfumato* as matter, from mineral to sand, dust, smoke and air, is the subject of some of Leonardo's last drawings, of which twelve remain, all representing deluges and floods.[42] In these studies, prompted by personal interest rather than commissioned, Leonardo continues to develop a comparative approach to the forms and patterns generated by the movements of natural elements. His fascination with hair curls appears as early as the 1470s in the portrait of Ginevra de' Benci (illus. 64), and even before, in what might have been his first known intervention in a painting, a curly white dog in Verrocchio's *Tobias and the Angel* (*c.* 1475) (illus. 65, 66).[43] We also encounter it in some of the grotesque heads, where the expressive rendition of hair anticipates the *Deluge* drawings (see illus. 68). Several sheets of studies examine the ways running water changes form according to the obstacles placed in its stream and how it creates patterns comparable to those of hair curls (illus. 67, 68). Leonardo also looked at smoke patterns left by cannonballs.[44] These universal forms, which he deduced from observing natural movements and shapes, are among the constituent parts of the deluge studies in which Leonardo imagines movements of water, smoke and dust caused by 'darkness, wind,

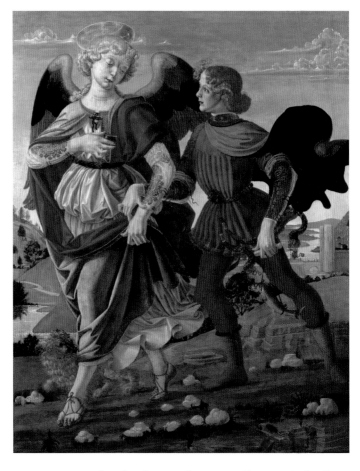

tempest at sea, floods of water, forests on fire, rain bolts from heaven, earthquakes and ruins of mountains, overthrow of cities'.[45]

The *Deluge, with a Falling Mountain and a Collapsing Town* (illus. 69) represents just this: the movement of a furious wind carrying bricks, houses, trees, smoke and dust. The drawing is also a formal *sfumato*, a progressive morphing of one form into

65 Andrea del Verrochio, *Tobias and the Angel*, c. 1470–75, tempera on poplar.

another, from the small parallelepipeds at the bottom of the drawing, expressive of a village, framed on the right by rows of curls and on the left by a spiral-shaped burst of boulders. The top part presents variations on hair curls in the centre, with thick foaming clouds above, and on the right, improvisations on the shape of oak leaves. On the left, the clouds with dented contours are reminiscent of the wheels and sprockets of Leonardo's machines as well as of the patterns of vegetal growth characteristic of his plant studies (illus. 70).

Michelangelo used the human body to express the movements of the soul; Leonardo used the natural elements for the same purpose. The deluge drawings encapsulate Leonardo's ability to contain and express the most violent manifestations of the world in controlled and energetic universal forms. The same spirals of lines can express the graceful curls of Ginevra de' Benci or of St John the Baptist, or the whirlwinds of dust generated by a storm or by the steps of horses on battlefields. This idealization reaches its peak in the deluge drawings,

66 Andrea del Verrochio, *Tobias and the Angel* (illus. 65), detail.

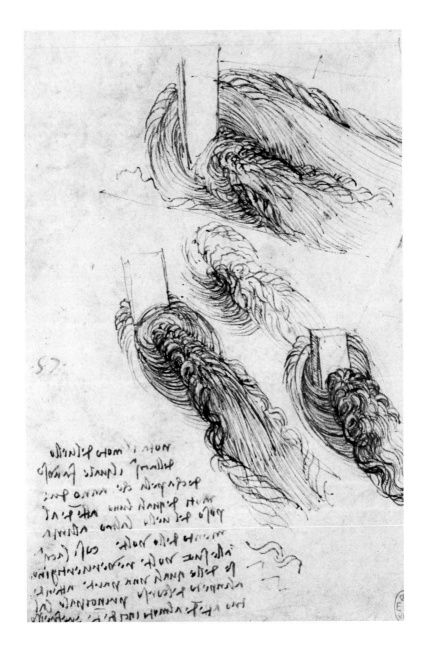

67 Leonardo da Vinci, *Studies and Notes on the Movement of Water*, c. 1512–13, pen and ink.

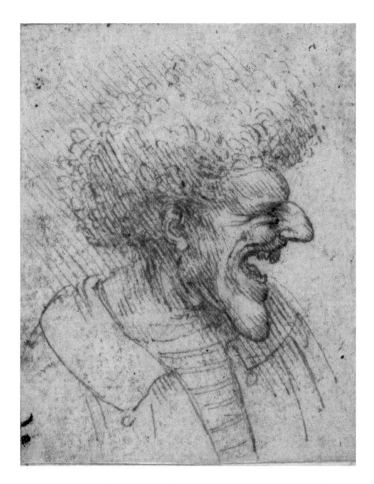

where curls and curves are the actors of a monumental ballet
of clouds, winds, dusts, trees and bricks. Whether it is the fire
of artillery or the fury of the elements, Leonardo understood
the entire world as a natural phenomenon.

Scholars have recently observed that the distinction
between nature and culture is a post-Renaissance ideology
that has no parallel in other cultures.[46] Leonardo's practice of

68 Leonardo da Vinci, *Grotesque Head with Bushy Hair*, c. 1495, pen and brown ink.

painting as a means of erasing his personal self to become a mirror of nature is one way of articulating this lack of distinction. This sense of presence in the world and detachment from personal emotions characterizes Leonardo's representation of war, as well as of floods, as a release of energies rather than a moral aberration. Although he once referred to war as a *pazzia bestialissima*, a most beastly madness,[47] these two words weigh little compared to his achievements and high reputation as a military engineer. He did however serve those responsible for the wars that ravaged Italy and was therefore partly responsible for the sufferings and deaths of thousands. There is no trace of anti-militarism in his writings, although some of his caricatures are reminiscent of the mockery of sharp-witted courtiers engaging with unrefined military men.

69 Leonardo da Vinci, *Deluge, with a Falling Mountain and a Collapsing Town*, one of a series of eleven drawings of a mighty deluge, *c.* 1517–18, black chalk.

It is difficult to associate the deluge studies firmly with events in Leonardo's life on the assumption that the world they represent echoes specific biographical events and their aftermaths. The deluge drawings date from around 1515, maybe 1516 – that is, the end of the Roman period and a

70 Leonardo da Vinci, *Study of Star-of-Bethlehem between Creeping Buttercup and Wood Anemone*, c. 1506–12, red chalk, pen and ink.

time when Leonardo's world was changing. With the death of his patron Giuliano de' Medici, he had to find employment elsewhere. Pope Leo X, another son of Lorenzo il Magnifico, Leonardo's first mentor, had no interest in him. All the commissions of the bustling art world of early sixteenth-century Rome, the so-called High Renaissance, went to his younger rivals or to lesser artists than him. He may at the time have written that the Medici 'created and destroyed him', but there is little evidence that Leonardo's world really was collapsing, and even less that he felt destroyed for very long. On the day his patron died he was invited to France, where he continued to flourish in material comfort. Perhaps two of the paintings he kept with him until the end hint at the keynote of his last years. A painting is not only something that we look at but something through which someone looks at the world, as well as something that looks back at us. This being so then the *St John the Baptist* and the *Mona Lisa*, on which Leonardo worked until his last days, stand out as evidence that he spent the last years of his life literally smiling at himself.

Conclusion

eonardo had good reasons to smile at himself. From the fifteenth century onwards, European artists were aspiring to be recognized as intellectuals, on an equal footing with writers, mathematicians, philosophers and astrologers (illus. 71). Leonardo was the first to truly make it, and probably the first artist to have become an international celebrity, eagerly sought after for his company and his work by kings and rulers, living like a philosopher-prince with his assistants, his servants and his horses. Thus in spite of some disasters and disappointments he led a comfortable life. Even if he found himself excluded from the great building site that was Renaissance Rome, we do not have much evidence of any bitterness on his part, and he instead moved to France to take up a huge pension and live in a castle. Although he was sometimes too ambitious for the technical possibilities of his time, his writings do not bear traces of indignation, wounded pride, offended sensitivity, boastfulness, self-righteousness or other manifestations of egotism so common in other artist- and artisan-writers, for example Benvenuto Cellini and Bernard Palissy.

In fact the man who achieved such a spectacular social and intellectual ascension practised methods of shaping his

self through painting. His observations on the proverb *ogni pittore dipinge se stesso* – each artist depicts himself – are less about self-erasure than about erasing individual idiosyncrasy in favour of an idealized nature shaped by a good artistic education. It is indeed an irony of history that by creating a style intended to obliterate the artist's individualistic self, Leonardo produced images that eventually became the most expensive in the world, precisely on account of the identification of the hand that he was working so hard on making invisible, or at least impersonal.

Leonardo's universality is not a consequence of his schooling but of the ways in which he fashioned himself, embracing the world which he accessed through the sophisticated artistic culture of the Renaissance. Yet his life was not one of asceticism but of stellar social ascension. From the table of peasants to the banqueting halls of rulers and the comfort of his own castle, his civic self covers the whole gamut of Renaissance society.

To become a perfect court artist, Leonardo had to understand the courtly world and gently model himself to its ideals. He did so well in this that he might even have contributed to Castiglione's elaboration of the Renaissance ideal of the perfect courtier. What he achieved by fashioning himself to the ideals of his time he correspondingly did in painting by introducing the technique of *sfumato*. Applied to social practice, Leonardo's *sfumato* is a method of gently blending with one's environment and interlocutors. It is a non-invasive way of blurring outlines and enclosures, of generating the effect of presence through the penetrating tones, accents and textures of the voice, through manners, body language, humour, wit and eloquence.

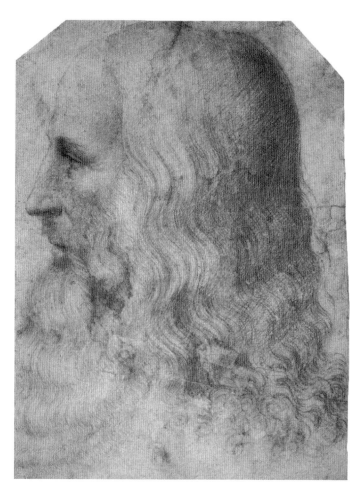

Alongside this multifaceted public embodiment of the human
ideal of his time Leonardo lived an unusually independent
life during which he successfully protected his privacy and
thinking space from external disruptions.

These contrasts between the private and public sides of
Leonardo resonate with the malleability of the self in modern

71 Francesco Melzi, *Portrait of Leonardo da Vinci, c.* 1515–18, red chalk.

art and popular culture – as shaped by figures ranging from Cindy Sherman to David Bowie, Madonna to Lady Gaga. Unlike today's celebrities, however, who defend causes and pressurize those in power, Leonardo showed no spirit of rebellion. He had anti-clerical feelings and sympathies with the pre-Reformation, but he was neither a dissident nor a rebel.

Since Freud's famous essay on Leonardo, 'A Memory of His Childhood' (1910), and a document dated 1476 alleging that he was involved in a sodomy case,[1] scholars have approached Leonardo's self in terms of his sexuality.[2] Yet, apart from one anatomical drawing and some brief remarks, he seems to have spent very little time on this subject. Unlike Michelangelo, whose works rely on the expressive potential of the male body, Leonardo's painting embraced the entire world in theory and practice. And while it could be argued that sex and desire were driving forces in the art of Michelangelo, they are very minor elements in the art of Leonardo.

Like some of his peers Leonardo was a multimedia artist. His life and work expand from the flat surface of painting to the natural world, which he used and manipulated to build machines, dig canals, divert rivers, move armies and destroy fortresses. His idea of using the world as his own medium has exercised much appeal to twentieth-century artists, from Joseph Beuys (1921–1986) to the pioneers of Land art such as Richard Long or Robert Smithson.

Beuys in particular had much interest in Leonardo and his notebooks. Beuys's own account of his performance piece *How to Explain Pictures to a Dead Hare* (1965) states that humans are not separate from nature but are part of it, to the extent that to damage nature is to damage ourselves[3] – an idea made

concrete by current issues of pollution and climate change. Such views have penetrated twentieth-century culture in the arts, politics, science and philosophy. While phenomenology opened the boundaries between the self and the world, António Damásio's *Descartes' Error* (1994) stands out as one of many symptoms of a late twentieth-century cognitive turn in which neuroscientists have reasserted the omnipresent interconnectedness of the thinking self with the world. In the sixteenth century, neuroscience and global environmental pollution were still to come, yet Leonardo's understanding of the world is indeed compatible with much twentieth- and twenty-first-century thought. Leonardo and his contemporaries understood themselves as part of the world: for them consciousness was not separate from nature, but rather an attribute of nature in the human.

Chronology

1506	Leonardo works on the *Mona Lisa*. He leaves for Milan in September, at the request of the French governor Charles d'Amboise
1507	Leonardo is back in Florence where he continues work on the *Battle of Anghiari*. Performs dissections and anatomical studies. By September he is back in Milan
1508	Leonardo settles in Milan
1509	*De divina proportione* by Luca Pacioli is published in Venice, illustrated with woodcuts after designs by Leonardo
1510	Anatomical studies, works as architectural consultant
1512	The French are expelled from Lombardy. Leonardo leaves Milan. The Medici return to Florence
1513	Leonardo moves to Rome as part of the household of Giuliano de' Medici
1514	Works on a canal project south of Rome to drain the Pontine marshes and on improvements for the port of Civitavecchia
1515	The French recapture Milan after the Battle of Marignan. A mechanical lion invented and built by Leonardo greets the French king Francis I in Lyon
1516	Death of Giuliano de' Medici. Leonardo moves to France
1517	Leonardo works on architecture and canal projects at Romorantin and is involved in the organization of feasts at Argentan
1518	Leonardo is involved in the organization of a feast at Amboise, including a re-enactment of the Battle of Marignan
1519	Leonardo dies in Cloux on 2 May

REFERENCES

Introduction

1 John Jeffries Martin, 'The Myth of Renaissance Individualism', in *A Companion to the Worlds of the Renaissance*, ed. Guido Ruggiero (Oxford, 2002), pp. 209–24: p. 210.

2 Giorgio Vasari, *Le vite de' più eccellenti pittori scultori e architettori: nelle redazioni del 1550 e 1568*, ed. Rosanna Bettarini and Paola Barocchi, (Florence, 1966), vol. IV, p. 21. A searchable edition is at http://vasari.sns.it/consultazione/Vasari/indice.html.

3 Romain Descendre, 'La biblioteca di Leonardo', in *Atlante della letteratura italiana*, ed. S. Luzzatto and G. Pedullà, vol. I (Turin, 2010), pp. 592–5.

4 Jean Paul Richter, ed., *The Literary Works of Leonardo da Vinci* (London, 1883), para 847.

5 Luca Beltrami, ed., *Documenti e memorie riguardanti la vita e le opere di Leonardo da Vinci: in ordine cronologico* (Milan, 1919), pp. 4–5; Michael Rocke, *Forbidden Friendships: Homosexuality and Male Culture in Renaissance Florence* (New York, 1996), p. 15.

6 For a survey of Leonardo studies see Kim H. Veltman, 'Leonardo da Vinci: A Review', *Leonardo*, XLI/4 (2008), pp. 381–8.

1 The Early Florentine Years: Education and Formation

1 On Leonardo's early years see David Alan Brown, *Leonardo da Vinci: Origins of a Genius* (New Haven, CT, 1998).

2 Andrew Butterfield, *The Sculptures of Andrea del Verrocchio* (New Haven, CT, 1997), pp. 232–3.

3 See Roberta Panzanelli, 'Compelling Presence: Wax Effigies in Renaissance Florence', in *Ephemeral Bodies: Wax Sculpture and the Human Figure*, ed. Roberta Panzanelli (Los Angeles, CA, 2008), pp. 13–39.

4 Cennino Cennini, *Il libro dell'arte, o Trattato della pittura*, ed. F. Tempesti (Milan, 1975), pp. 146–52.

5 Dario A. Covi, 'Verrocchio and Venice, 1469', *Art Bulletin*, LXV/2 (1983), pp. 253–73: pp. 254–5.

6 Butterfield, *The Sculptures of Andrea del Verrocchio*, p. 4; Brown, *Leonardo da Vinci*, pp. 123–6.

7 Leon Battista Alberti, *On Painting*, trans. John R. Spencer (New Haven, CT, 1966), p. 73.

8 Vasari, *Le Vite*, vol. IV, p. 19. Verrocchio always used pupils to assist him in painting; the question of Verrocchio as a painter is highly debated since very few documents remain. See Butterfield, *The Sculptures of Andrea del Verrocchio*, pp. 191–7.

9 Jean Paul Richter, ed., *The Literary Works of Leonardo da Vinci* (London, 1883), para 498.

10 Frank Zöllner and Johannes Nathan, *Leonardo da Vinci, 1452–1519: The Complete Paintings and Drawings* (Cologne, 2015), p. 18.

11 Keith Christiansen, 'Giovanni Bellini and the Practice of Devotional Painting', in *Giovanni Bellini and the Art of Devotion*, ed. Ronda Kasl (Indianapolis, IN, 2004), pp. 7–58: p. 36. See also R. W. Lightbown, *Carlo Crivelli* (New Haven, CT, 2004), pp. 15–16.

12 David Bull, 'Portraits by Leonardo: *Ginevra de' Benci* and the *Lady with an Ermine*', *Artibus et Historiae*, XIII/25 (1992), p. 80.

13 Marcello Simonetta, *The Montefeltro Conspiracy* (New York, 2008).

14 Francis William Kent, *Lorenzo de' Medici and the Art of Magnificence* (Baltimore, MD, 2004), p. 39.

15 Giorgio Vasari, *Lives of the Most Eminent Painters, Sculptors and Architects*, ed. and trans. Gaston du C. de Vere (London, 1912), vol. IV, p. 184; on the Medici garden see Caroline Elam, 'Lorenzo de' Medici's Sculpture Garden', *Mitteilungen des Kunsthistorischen Institutes in Florenz*, XXVI/1–2 (1992), pp. 41–84.

16 Richter, *Literary Works*, para 660.

17 Kent, *Lorenzo de' Medici*, p. 18; P. Nuttall, 'The Medici and Netherlandish Painting', in *The Early Medici and their Artists*, ed. F. Ames-Lewis (London, 1995), pp. 135–52.

18 Aristotle, *Politics: A Treatise on Government*, VIII.3.1338a–b: 'thus they should be instructed in painting, not only to prevent their being mistaken in purchasing pictures, or in buying or selling of vases, but rather as it makes [1338b] them judges of the beauties of the human form.'

19 Lina Bolzoni, 'Ginevra de' Benci: un portrait entre les mots et l'image, entre Léonard de Vinci et Bembo', *Monuments et mémoires de la Fondation Eugène Piot*, XCI/1 (2012), pp. 149–62: p. 159.

20 Ibid.

21 Mary D. Garrard, 'Who Was Ginevra de' Benci? Leonardo's Portrait and its Sitter Recontextualized', *Artibus et Historiae*, XXVII/53 (2006), pp. 23–56: p. 25.

22 Jennifer Fletcher, 'Bernardo Bembo and Leonardo's Portrait of Ginevra de' Benci', *Burlington Magazine*, CXXXI/1041 (1989), pp. 811–16.

23 Garrard, 'Who was Ginevra de' Benci?', p. 37.

24 Ibid., pp. 44–5.

25 Ibid., p. 43.

26 See Brown, *Leonardo da Vinci*, pp. 108–9, including a computer reconstruction.

27 Garrard, 'Who was Ginevra de' Benci?', pp. 42, 51.

28 Richter, *Literary Works*, para 654.

29 Marsilio Ficino, *El libro dell'amore*, ed. Sandra Niccoli (Florence, 1987), Book V, Ch. 2, para 6.

30 G. Toffanin, 'Petrarchismo e Trattati d'amore nel Rinascimento', *Nuova Antologia*, CCLVIII (1928), p. 9. On Ficino's influence in the sixteenth century see Stephen Clucas, Peter J. Forshaw and Valery Rees, eds, *Laus Platonici Philosophi: Marsilio Ficino and his Influence*, Brill's Studies in Intellectual History 198 (Leiden, 2011).

31 See Joan Kelly-Gadol, 'Did Women Have a Renaissance?', in *Women, History and Theory: The Essays* (Chicago, IL, 1984), pp. 19–49.

32 Ibid.

33 C. Pedretti, 'Li Medici mi crearono e desstrussono', *Achademia Leonardi Vinci*, 6 (1993), pp. 173–84.

2 Leonardo on Painting

1 Luca Beltrami, ed., *Documenti e memorie riguardanti la vita e le opere di Leonardo da Vinci: in ordine cronologico* (Milan, 1919), p. 7.

2 See Claire J. Farago et al., eds, *The Fabrication of Leonardo da Vinci's 'Trattato della pittura', with a Scholarly Edition of the Italian 'Editio princeps' (1651) and an Annotated English Translation* (Leiden, 2018).

3 Ibid., p. 47 n. 2.

4 Ibid., p. 26.

5 See also Leon Battista Alberti, *On Painting*, trans. John R. Spencer (New Haven, CT, 1966), p. 79.

6 Frank Zöllner and Johannes Nathan, *Leonardo da Vinci, 1452–1519: The Complete Paintings and Drawings* (Cologne and London, 2015), p. 6 and cat. xxiii, xxiv, xxvi, xxvii, xxix.

7 Luke Syson and Larry Keith, *Leonardo da Vinci: Painter at the Court of Milan* (New Haven, CT, 2011), p. 72.

8 The headings were 1. Introduction and Comparison of the Arts; 2. Precepts for the Painter; 3. On the Various Movements of Humans and the Proportion of their Limbs; 4. On Drapery and the Manner of Clothing Figures with Grace; 5. On Shadow and Light; 6. On Trees and Greenery; 7. On Clouds; 8. On the Horizon. Farago et al., eds, *The Fabrication of Leonardo da Vinci's 'Trattato'*, pp. 76–7.

9 Ibid., p. 799.

10 Ibid., pp. 151–3,

11 *The Literary Works of Leonardo da Vinci*, ed. Jean Paul Richter (London, 1883), paras 485–7.

12 Farago et al., eds, *The Fabrication of Leonardo da Vinci's 'Trattato'*, p. 672.

13 Richter, *Literary Works*, para 491.

14 Ibid., n. 572.

15 Martin Kemp, *Leonardo da Vinci: The Marvellous Works of Nature and Man* (Oxford, 2006), pp. 251–6.

16 Michael Baxandall, *Painting and Experience in Fifteenth-century Italy: A Primer in the Social History of Pictorial Style* (Oxford, 1972), pp. 86–93.

17 Richter, *Literary Works*, para 507.

18 Ibid., para 495.

19 Ibid., para 508. Translation from Farago et al., eds, *The Fabrication of Leonardo da Vinci's 'Trattato'*, p. 670. See also Richter, *Literary Works*, para 496: 'I myself have proved it to be of no small use, when in bed, in darkness, to recall in imagination the external details of forms, previously studied, or other things thought of through noteworthy speculations . . . and this is certainly an admirable and useful exercise for impressing things on the memory.'

20 Ibid., para 508.

21 Ibid., para 529.

22 Ibid., para 586.

23 Frank Zöllner, '"Ogni pittore dipinge sé": Leonardo da Vinci and "Automimesis"', in *Der Künstler über sich in seinem Werk. Internationales Symposium der Bibliotheca Hertziana*, ed. Matthias Winner (Weinheim, 1992), pp. 137–60: p. 141.

24 Richter, *Literary Works*, para 506.

25 Ibid., paras 836–9.

26 Review of literature in Michael W. Kwakkelstein, 'Leonardo da Vinci's Drawings of Monstrous Heads: Creative Inventions or Observed Realities?', in *Ear, Nose and Throat in Culture*, ed. W. Pirsig and J. Willemut (Ostend, 2001), pp. 223–42.

27 E. H. Gombrich, 'Grotesque Heads', in *The Heritage of Apelles* (London, 1976), p. 69.

28 Kemp, *Leonardo da Vinci*, p. 142.

29 Gombrich, 'Grotesque Heads', p. 71.

30 Zöllner and Nathan, *Leonardo da Vinci*, p. 50. Contract in Beltrami, *Documenti*, p. 7.

31 See for example Alexander Nagel, 'Leonardo and Sfumato', RES: *Anthropology and Aesthetics*, XXIV (1993), pp. 7–20: p. 13, who characterizes Leonardo's practice of presenting works 'as nothing more (and nothing less) than the exploration of expressive possibilities, independent of prescribed subject matter'.

32 On the wooden statue for which the *Virgin of the Rocks* might have served as a screen see Zöllner and Nathan, *Leonardo da Vinci*, p. 64. On miraculous images and their appearance see Jane Garnett and Gervase Rosser, *Spectacular Miracles: Transforming Images in Italy, from the Renaissance to the Present* (London 2013), pp. 23–7.

33 Leonardo da Vinci, *Treatise on Painting (Codex Urbinas Latinus 1270)*,
 ed. A. Philip McMahon (Princeton, NJ, 1956), p. 18.

34 Richter, *Literary Works*, para 1295.

35 Ibid., para 1293.

36 Ibid., para 1280.

37 Translation from Giorgio Vasari, *Lives of the Most Eminent Painters,
 Sculptors and Architects*, ed. and trans. Gaston du C. de Vere
 (London, 1912), vol. IV, p. 100.

3 Milan, 1483–99

1 Virginia L. Bush, 'Leonardo's Sforza Monument and Cinquecento
 Sculpture', *Arte Lombarda*, 50 (1978), pp. 47–68: p. 49; and Patrick
 Boucheron, 'La Statue équestre de Francesco Sforza: Enquête sur
 un mémorial politique', *Journal des Savants*, 11/1 (1997), pp. 421–99:
 p. 447.

2 *Il Codice Magliabechiano Cl. xvii. 17: contenente notizie sopra l'arte degli
 antichi e quella de' Fiorentini da Cimabue a Michelangelo Buonarroti,
 scritte da anonimo Fiorentino*, ed. Karl Frey (Berlin, 1892), p. 110
 (my translation).

3 See Martin Warnke, *The Court Artist: On the Ancestry of the Modern
 Artist* (Cambridge, 1993).

4 Boucheron, 'La statue équestre', pp. 447–54.

5 Paolo Giovio, 'The Life of Leonardo da Vinci/ Leonardi Vincii
 Vita' [1527], reprinted in *Leonardo da Vinci: Biography and Early Art
 Criticism*, ed. Claire Farago (New York, 1999), p. 70.

6 See Giorgio Vasari, *Lives of the Most Eminent Painters, Sculptors and
 Architects*, ed and trans. Gaston du C. de Vere (London 1912),
 vol. IV, p. 89: 'nel quale oltra la bellezza del corpo, non lodata
 mai aba-stanza, era la grazia più che infinita in qualunque sua
 azzione; e tanta e sì fatta poi la virtù, che dovunque l'animo volse
 nelle cose difficili, con facilità le rendeva assolute. La forza in lui
 fu molta, e congiunta con la destrezza, l'animo e 'l valore sempre
 regio e magnanimo'.

7 Ibid., vol. IV, p. 91.

8 Norbert Elias, *The Civilizing Process* (Oxford, 1978).

9 Castiglione, *Il cortegiano*, IV, 4.

10 Ibid., 1, 27. See also Claire J. Farago et al., eds, *The Fabrication of Leonardo da Vinci's 'Trattato della pittura', with a Scholarly Edition of the Italian 'Editio princeps' (1651) and an Annotated English Translation* (Leiden, 2018), p. 215.

11 Translation from *The Book of the Courtier by Count Baldassare Castiglione*, trans. Leonard Eckstein Opdycke (New York, 1903). Castiglione, *Il cortegiano* 1.26: 'Ma avendo io già piú volte pensato meco onde nasca questa grazia, lasciando quelli che dalle stelle l'hanno, trovo una regula universalissima, la qual mi par valer circa questo in tutte le cose umane che si facciano o dicano piú che alcuna altra, e ciò è fuggir quanto piú si po, e come un asperissimo e pericoloso scoglio, la affettazione; e, per dir forse una nova parola, usar in ogni cosa una certa sprezzatura, che nasconda l'arte e dimostri ciò che si fa e dice venir fatto senza fatica e quasi senza pensarvi. Da questo credo io che derivi assai la grazia.'

12 Vasari, *Lives*, vol. IV, p. 89.

13 Castiglione, *Il cortegiano*, 1, 26: 'E come la pecchia ne' verdi prati sempre tra l'erbe va carpendo i fiori, cosí il nostro cortegiano averà da rubare questa grazia da que' che a lui parerà che la tenghino e da ciascun quella parte che piú sarà laudevole.'

14 Ibid., 1, 5: 'feste e musiche e danze che continuamente si usavano, talor si proponeano belle questioni, talor si faceano alcuni giochi ingeniosi ad arbitrio or d'uno or d'un altro, ne' quali sotto varii velami spesso scoprivano i circonstanti allegoricamente i pensier sui a chi piú loro piaceva. Qualche volta nasceano altre disputazioni di diverse materie, o vero si mordea con pronti detti; spesso si faceano imprese come oggidì chiamiamo; dove di tali ragionamenti maraviglioso piacere si pigliava per esser, come ho detto, piena la casa di nobilissimi ingegni.'

15 Jean Paul Richter, ed., *The Literary Works of Leonardo da Vinci* (London, 1883), para 1293.

16 Ibid., para 1295.

17 Ibid., para 1297.

18 Ibid., para 1295.

19 Ibid., para 1267.

20 Ibid., para 1272.

21 Ibid., para 1279.

22 Monica Azzolini, 'In Praise of Art: Text and Context of
 Leonardo's "Paragone" and its Critique of the Arts and Sciences',
 Renaissance Studies, XIX/4 (2005), pp. 487–510.

23 Castiglione, *Il cortegiano*, I, 49–52.

24 Claire J. Farago, *Leonardo da Vinci's 'Paragone': A Critical Interpretation
 with a New Edition of the Text in the Codex Urbinas* (Leiden, 1992).

25 Bernardo Bellincioni, *Le Rime di Bernardo Bellincioni, riscontrate
 sui manoscritti*, ed. Pietro Fanfani (Bologna, 1876), p. 26.
 'Quivi è sol de Parnaso el monte santo,/ E come l'ape al mel,
 viene ogni dotto:/ Quel Calco è Meceneate, e ben n'ha 'l vanto./
 Un nuovo Marziale v'è, che è il Pelotto/ Galieno, Avicenna,
 e Ipocrate;/ Da Fiorenza uno Apelle qui ha condotto:/
 Cose, che par natura abbi formate/ Architettori e vari
 ingegni tanti.'

26 Vasari, *Le Vite*, vol. IV, p. 18: 'oltreché perse tempo fino a disegnare
 gruppi di corde fatti con ordine, e che da un capo seguissi tutto il
 resto fino a l'altro, tantoché s'empiessi un tondo, che se ne vede in
 istampa uno difficilissimo e molto bello, e nel mezzo vi sono queste
 parole: LEONARDUS VINCI ACCADEMIA'.

27 On Renaissance academies see Simone Testa, *Italian Academies and
 their Networks, 1525–1700: From Local to Global* (Basingstoke, 2015).

28 Jill Pederson, 'Henrico Boscano's "Isola Beata": New Evidence for
 the Academia Leonardi Vinci in Renaissance Milan', *Renaissance
 Studies*, XXII/4 (2008), pp. 450–75.

29 Boscano, *Isola Beata* (MS, private collection), fol. 9v, quoted ibid.,
 p. 453: 'che la tua casa era la fucina e il cimento delli savi e
 l'academia di molti signori, conti e cavalieri, philosophi e poeti,
 e musici, tutti adornati da virtu e boni costumi'.

30 Richter, *Literary Works*, para 990.

31 Joseph Manca, 'The Gothic Leonardo: Towards a Reassessment
 of the Renaissance', *Artibus et Historiae*, XVII/34 (1996), pp. 121–58:
 p. 145.

32 Richter, *Literary Works*, para 704.

33 Frank Zöllner and Johannes Nathan, *Leonardo da Vinci, 1452–1519:
 The Complete Paintings and Drawings* (Cologne and London, 2015),
 pp. 135, 233.

34 Janice Shell and Grazioso Sironi, 'Cecilia Gallerani: Leonardo's *Lady with an Ermine*', *Artibus et Historiae*, XIII/25 (1992), pp. 47–66: pp. 57–8.

35 Luke Syson and Larry Keith, *Leonardo da Vinci: Painter at the Court of Milan* (London, 2011), p. 122.

36 Shell and Sironi, 'Cecilia Gallerani', p. 53.

37 Syson and Keith, *Leonardo da Vinci*, pp. 111–13.

38 On the ermine in the Renaissance, see Jacqueline Marie Musacchio, 'Weasels and Pregnancy in Renaissance Italy', *Renaissance Studies*, XV/2 (2001), pp. 172–87.

39 Farago et al., eds, *The Fabrication of Leonardo da Vinci's 'Trattato'*, p. 799.

40 L. Beltrami, *Documenti e memorie riguardanti la vita e le opere di Leonardo da Vinci: in ordine cronologico* (Milan, 1919), pp. 12–18; summarized in Zöllner and Nathan, *Leonardo da Vinci*, p. 64, who point out that it might also have been exposed next to Leonardo's panel.

41 Contract published in Beltrami, *Documenti*, pp. 12–18.

42 See Barbara Wisch and Diane Cole Ahl, eds, *Confraternities and the Visual Arts in Renaissance Italy: Ritual, Spectacle, Image* (Cambridge, 2000).

43 Zöllner and Nathan, *Leonardo da Vinci*, p. 67.

44 Beltrami, *Documenti*, pp. 13–14.

45 Farago et al., *The Fabrication of Leonardo da Vinci's 'Trattato'*, p. 804.

46 Harold M. Priest, 'Marino, Leonardo, Francini, and the Revolving Stage', *Renaissance Quarterly*, XXXV/1 (1982), pp. 36–60: p. 43. Kate T. Steinitz, 'Les Décors de théâtre de Léonard de Vinci. Paradis et Enfer', *Bibliothèque d'Humanisme et Renaissance*, XX/2 (1958), pp. 257–65. Edmondo Solmi, 'La festa del Paradiso di Leonardo da Vinci e Bernardo Bellincione', in Edmondo Solmi and Arrigo Solmi, *Scritti Vinciani* (Florence, 1924), pp. 3–15.

47 Zöllner and Nathan, *Leonardo da Vinci*, p. 230.

48 Joseph Polzer, 'Reflections on Leonardo's "Last Supper"', *Artibus et Historiae*, XXXII/63 (2011), pp. 9–37: p. 31.

49 Thomas Brachert, 'A Musical Canon of Proportion in Leonardo da Vinci's *Last Supper*', *Art Bulletin*, LIII/4 (1971), pp. 461–6.

50 Zöllner and Nathan, *Leonardo da Vinci*, p. 231.

51 John L. Varriano, *Tastes and Temptations: Food and Art in Renaissance Italy* (Berkeley, CA, 2009), pp. 101–5.

52 Ibid., p. 100.

53 Ibid., p. 101.

54 Bandello, *Le Novelle* [1554] (Bari, 1910), vol. 11, p. 283, translation from Polzer, 'Reflection on Leonardo's "Last Supper"', p. 12.

55 Boucheron, 'La Statue équestre', pp. 454, 495.

56 Virginia Bush, 'Leonardo's Sforza Monument and Cinquecento Sculpture', *Arte Lombarda*, L (1978), pp. 47–68: p. 56.

57 Ibid., p. 61.

58 Vasari, *Le Vite*, vol. IV, p. 27: 'e nel vero quelli che veddono il modello che Lionardo fece di terra, grande, giudicano non aver mai visto più bella cosa né più superba'.

59 Beltrami, *Documenti*, p. 209: 'Vedi che in corte fa far di metallo/ per memoria dil padre un gran colosso/ i credo fermamente e senza fallo/ che Gretia e Roma mai vide el più grosso./ Guarde pur come è bello quel cauallo/ Leonardo da Vinci a farlo sol s'è mosso./ Statura bon pictore e bon geometra/ Un tanto ingegno rar dal ciel s'impetra.'

60 Martin Kemp, *Leonardo da Vinci: The Marvellous Works of Nature and Man* (Cambridge, MA, 1981), p. 203.

61 Bush, 'Leonardo's Sforza Monument', p. 39.

62 Boucheron, 'La Statue équestre', pp. 481–4.

63 Pascal Brioist, *Léonard de Vinci: homme de guerre* (Paris, 2013), loc. 993 (Kindle edition).

64 Ibid., loc. 1288.

65 Ibid., loc. 1464.

66 Published in Beltrami, *Documenti*, pp. 11–12. See also Richter, *Literary Works*, para 1340. The letter is known only through a copy.

4 Florence to Milan, 1500–1513

1 L. Beltrami, *Documenti e memorie riguardanti la vita e le opere di Leonardo da Vinci: in ordine cronologico* (Milan, 1919), p. 62: 'Il duca perso lo stato e la roba e libertà, e nessuna sua opera si finì per lui.'

2 *The Literary Works of Leonardo da Vinci*, ed. Jean Paul Richter (London, 1883), para 494.

3 Beltrami, *Documenti*, p. 72.

4 Ibid., p. 117.

5 P. G. Gwynne, 'A New Contribution to the Biography of Leonardo
 da Vinci', *Burlington Magazine*, CLI/1277 (2009), p. 543. Pascal
 Brioist, *Léonard de Vinci: homme de guerre* (Paris, 2013), loc. 2348
 (Kindle edition).

6 Ibid., loc. 2410.

7 Beltrami, *Documenti*, p. 11: 'con il fumo di quelle dando grande
 spavento all'inimico; con grave suo danno e confusione'.

8 Brioist, *Léonard de Vinci*, loc. 2395.

9 Ibid., loc. 844.

10 Martin Kemp, *Leonardo da Vinci: The Marvellous Works of Nature and Man*
 (Cambridge, MA, 1981), p. 308.

11 Brioist, *Léonard de Vinci*, loc. 2532.

12 Ibid., loc. 2762.

13 Marco Formisano, introduction to *War in Words: Transformations of
 War from Antiquity to Clausewitz*, ed. M. Formisano and H. Böhme
 (Berlin and New York, 2011), pp. 4–6.

14 Brioist, *Léonard de Vinci*, loc. 2172

15 Beltrami, *Documenti*, pp. 86–9; Frank Zöllner and Johannes
 Nathan, *Leonardo da Vinci, 1452–1519: The Complete Paintings and Drawings*
 (Cologne and London, 2015), pp. 164–8.

16 Carmen C. Bambach, 'The Purchases of Cartoon Paper for
 Leonardo's "Battle of Anghiari" and Michelangelo's "Battle of
 Cascina"', *I Tatti: Studies in the Italian Renaissance*, 8 (1999): pp. 105–33:
 p. 125.

17 Zöllner and Nathan, *Leonardo da Vinci*, p. 242.

18 Richter, *Literary Works*, para 601.

19 Ibid.

20 Ibid., para 602.

21 Ibid.

22 Ibid.

23 Zöllner and Nathan, *Leonardo da Vinci*, p. 173.

24 Richter, *Literary Works*, para 602.

25 Quoted in Leonardo da Vinci, *Notebooks*, ed. Irma Richter
 (Oxford, 2008), p. 333.

26 Zöllner and Nathan, *Leonardo da Vinci*, p. 248.

27 Beltrami, *Documenti*, p. 65: 'per quanto me occorre la vita di
 Leonardo è varia et indeterminata forte, si che pare vivere a

giornata . . . Altro non ha facto, se non dui suoi garzoni fano retrati, e lui a le volte in alcuno mette mano.'

28 Ibid., p. 66: 'insumma li suoi esperimenti matematici l'hanno distratto tanto dal dipingere che non può patire il pennello.'

29 David Chambers and Jane Martineau, eds, *Splendours of the Gonzaga*, exh. cat., Victoria & Albert Museum, London (London, 1981), p. 24.

30 Zöllner and Nathan, *Leonardo da Vinci*, p. 188; Barbara Hochstetler Meyer, 'Leonardo's Hypothetical Painting of "Leda and the Swan"', *Mitteilungen des Kunsthistorischen Institutes in Florenz*, XXXIV/3 (1990), pp. 279–94.

31 Barbara Hochstetler Meyer and Alice Wilson Glover, 'Botany and Art in Leonardo's "Leda and the Swan"', *Leonardo*, XXII/1 (1989), pp. 75–82. Martin Kemp, *Leonardo da Vinci: The Marvellous Works of Nature and Man* (Cambridge, MA, 1981), pp. 263–9.

32 Edmondo Solmi and Arrigo Solmi, *Scritti Vinciani* (Florence, 1924), p. 381. On swans see Richter, *Literary Works*, para 1238.

33 Andrew Butterfield, *The Sculptures of Andrea del Verrocchio* (New Haven, CT, and London, 1997), pp. 29, 222–3.

34 Marsilio Ficino, *El libro dell'amore*, ed. Sandra Niccoli (Florence, 1987), II, 7.

35 Richter, *Literary Works*, para 529, and see above, Chapter Two.

36 See for example Gerard David, *St Anne with the Virgin and Child* (*St Anne Altarpiece*, middle panel, *c.* 1500), National Gallery of Art, Washington, DC, 1942.9.17b.

37 Edward McCurdy, *Leonardo da Vinci: The Artist* (London, 1933), p. 194.

38 Beltrami, *Documenti*, pp. 65–6.

39 Jack M. Greenstein, 'Leonardo, Mona Lisa and "La Gioconda": Reviewing the Evidence', *Artibus et Historiae*, XXV/50 (2004), pp. 17–38: pp. 29–30.

40 Zöllner and Nathan, *Leonardo da Vinci*, pp. 250–51.

41 Ibid.

42 Beltrami, *Documenti*, p. 238: 'uno di certa dona Firentina facta di naturale ad istantia del quondam mag.co Juliano de Medici'.

43 Kemp, *Leonardo da Vinci*, p. 257.

44 Richter, *Literary Works*, para 929.

45 Kenneth D. Keele, 'The Genesis of Mona Lisa', *Journal of the History of Medicine and Allied Sciences*, XIV/2 (1959), pp. 135–59. For a round-up of the main interpretations of the *Mona Lisa* see Zöllner and Nathan, *Leonardo da Vinci*, p. 241.

46 Ibid., p. 8.

47 Brioist, *Léonard de Vinci*, loc. 3133.

48 Ibid., loc. 3184.

5 The Final Years: Rome and Amboise, 1513–19

1 Pascal Brioist, *Léonard de Vinci: homme de guerre* (Paris, 2013), loc. 3422 (Kindle edition).

2 Jean Paul Richter, ed., *The Literary Works of Leonardo da Vinci* (London, 1883), para 1465.

3 Vasari, *Le Vite*, vol. IV, pp. 34–5.

4 Richter, *Literary Works*, para 1351.

5 Sven Dupré, 'Optic, Picture and Evidence: Leonardo's Drawings of Mirrors and Machinery', *Early Science and Medicine*, X/2 (2005), pp. 211–36: p. 230.

6 Carlo Pedretti, Margherita Melani and Andrea Bernardoni, eds, *Leonardo da Vinci and France* (Ambroise, 2013), pp. 173–84.

7 Brioist, *Léonard de Vinci*, loc. 3536.

8 L. Beltrami, *Documenti e memorie riguardanti la vita e le opere di Leonardo da Vinci: in ordine cronologico* (Milan, 1919), p. 151.

9 Carlo Pedretti et al., eds, *Leonard de Vinci et La France* (Campi Bisenzio, 2013).

10 Ibid., p. 149: 'Ha ben facto un creato Milanese che lavora assai bene, et benché il p.to M. Lunardo non possa colorir con quella dulceza che solea, pur serve ad far disegni et insegnar ad altri.'

11 Frank Zöllner and Johannes Nathan, *Leonardo da Vinci, 1452–1519: The Complete Paintings and Drawings* (Cologne and London, 2015), p. 203.

12 Stuart W. Pyhrr et al., *Heroic Armor of the Italian Renaissance: Filippo Negroli and His Contemporaries* (New York, 1998), pp. 25–33.

13 See for example *Descrizione della giostra seguita in Padova nel giugno 1466* (Padua, 1852).

14 Richter, *Literary Works*, para 585.

15 Brioist, *Léonard de Vinci*, loc. 3595.

16 Richter, *Literary Works*, para 704.

17 Giorgio Vasari, *Le vite de' più eccellenti pittori scultori e architettori: nelle redazioni del 1550 e 1568*, ed. Rosanna Bettarini and Paola Barocchi (Florence, 1966), vol. IV, p. 28. Jill Burke, 'Meaning and Crisis in the Early Sixteenth Century: Interpreting Leonardo's Lion', *Oxford Art Journal*, XXIX/1 (2006), pp. 79–91: p. 80.

18 Edmondo Solmi and Arrigo Solmi, *Scritti Vinciani* (Florence, 1924), p. 342.

19 Ibid.

20 Ibid., p. 343: 'et epso Leone si aperse, et dentro era tutto azuro, che significava amore secondo il modo di qua.' 'E tucto se aperse. E'l color de dentro era turchino cum un giglio in mezzo.'

21 See https://marignan2015.univ-tours.fr, accessed 29 October 2018, for details, including an appendix of documents.

22 Solmi, *Scritti Vinciani*, p. 354.

23 Luca Garai, 'The Staging of the Besieged Fortress', in *Leonardo da Vinci and France*, ed. Pedretti, Melani and Bernardoni, pp. 141–6: p. 141.

24 Solmi, *Scritti Vinciani*, p. 347.

25 Royal Library, Windsor Castle, RL 12328.

26 Klaus Herding and Nina Schleif, 'Freud's Leonardo: A Discussion of Recent Psychoanalytic Theories', *American Imago*, LXVII/4 (2000), pp. 339–68: p. 350. Zöllner and Nathan, *Leonardo da Vinci*, p. 202.

27 Zöllner and Nathan, *Leonardo da Vinci*, p. 248. Paul Barolsky, 'The Mysterious Meaning of Leonardo's "Saint John the Baptist"', *Source: Notes in the History of Art*, VIII/3 (1989), pp. 11–15.

28 Giorgio Vasari, *Lives of the Most Eminent Painters, Sculptors and Architects*, ed. and trans. Gaston du C. de Vere (London, 1912), vol. IV, p. 89.

29 See for example Alexander Nagel, 'Leonardo and Sfumato', *RES: Anthropology and Aesthetics*, XXIV (1993), pp. 7–20: p. 13.

30 Richter, *Literary Works*, para 604.

31 G. P. Lomazzo, *Trattato dell'arte della pittura, scultura et architettura* (Milan, 1584), Book 7, pp. 527–680; Giovan Battista Armenini, *De' veri precetti dell'pittura* (Milan, 1820), Book 3, pp. 220–314.

32 Richter, *Literary Works*, para 1146.

33 See Nagel, 'Leonardo and Sfumato'; Claire J. Farago, 'Leonardo's Color and Chiaroscuro Reconsidered: The Visual Force of Painted Images', *Art Bulletin*, LXXIII/1 (1991), pp. 63–88.

34 See Introduction to this volume.

35 Edward J. Olszewski, 'How Leonardo Invented Sfumato', *Source: Notes in the History of Art*, XXXI/1 (2011), pp. 4–9.

36 Richter, *Literary Works*, para 300.

37 Ibid., para 301.

38 Ibid., para 305, see also para 469.

39 Ibid., para 616: 'Questa carta si debbe tigniere di fumo'.

40 Brioist, *Léonard de Vinci*, loc. 1848.

41 Richter, *Literary Works*, para 1081.

42 The Royal Collection, Windsor Castle, RL 12337, 12338, 12339, 12380, 12382, 12383, 12384, 12385, 12386, 12401, 12381, 12376.

43 David Alan Brown, *Leonardo da Vinci: Origins of a Genius* (New Haven, CT, 1998), pp. 47–51.

44 Brioist, *Léonard de Vinci*, loc. 1339.

45 Richter, *Literary Works*, para 609, see also paras 606–11 for several of Leonardo's descriptions of storms.

46 Philippe Descola, *Par-delà nature et culture* (Paris, 2015), p. 16.

47 Claire J. Farago et al., eds, *The Fabrication of Leonardo da Vinci's 'Trattato della pittura', with a Scholarly Edition of the Italian 'Editio princeps' (1651) and an Annotated English Translation* (Leiden, 2018), p. 672.

Conclusion

1 L. Beltrami, *Documenti e memorie riguardanti la vita e le opere di Leonardo da Vinci: in ordine cronologico* (Milan, 1919, pp. 4–5.

2 See for example Lea Dovev, '"On the Hand from Within": Palms, Selfhood and Generation in Leonardo's Anatomical Project', *Leonardo*, XLIII/1 (2010), pp. 63–9.

3 On Beuys and Leonardo see Joseph Beuys, *Drawings after the Codices Madrid of Leonardo da Vinci* (New York, 1998), and in particular Martin Kemp, 'The Notebook as Experimental Field', pp. 31–44 in the same volume.

BIBLIOGRAPHY

Online

The site e-leo (www.leonardodigitale.com) provides access to all of Leonardo's manuscripts. Biblioteca Leonadiana, www.bibliotecaleonardiana.it, is a useful portal to resources on Leonardo and provides access to the Bibliografia Internazionale Leonardiana, which exemplifies the exponential growth of studies and material available on Leonardo. (Both sites are in Italian.) The site www.universalleonardo.org offers an excellent overview of Leonardo's life and work.

Main Sources

Beltrami, Luca, ed., *Documenti e memorie riguardanti la vita e le opere di Leonardo da Vinci: in ordine cronologico* (Milano, 1919)

McCurdy, Edward, ed., *Leonardo da Vinci's Notebooks* (New York, 1935)

Richter, Jean Paul, ed., *The Literary Works of Leonardo da Vinci* (London, 1883)

Further Reading

Azzolini, Monica, 'In Praise of Art: Text and Context of Leonardo's "Paragone" and Its Critique of the Arts and Sciences', *Renaissance Studies*, XIX/4 (2005), pp. 487–510

Bambach, Carmen C., 'The Purchases of Cartoon Paper for Leonardo's "Battle of Anghiari" and Michelangelo's "Battle of Cascina"', *I Tatti Studies in the Italian Renaissance*, VIII (1999), pp. 105–33

Bellincioni, Bernardo, *Le Rime di Bernardo Bellincioni riscontrate sui manoscritti*, ed. Pietro Fanfani (Bologna, 1876)

Bolzoni, Lina, 'Ginevra de' Benci: un portrait entre les mots et l'image, entre Léonard de Vinci et Bembo', *Monuments et mémoires de la Fondation Eugène Piot*, XCI/1 (2012), pp. 149–62

Boucheron, Patrick, 'La Statue équestre de Francesco Sforza: Enquête sur un mémorial politique', *Journal des Savants*, 11/1 (1997), pp. 421–99

Brachert, Thomas, 'A Musical Canon of Proportion in Leonardo da Vinci's *Last Supper*', *Art Bulletin*, LIII/4 (1971), pp. 461–6

Brioist, Pascal, *Léonard de Vinci: homme de guerre* (Paris, 2013)

Britton, Piers D. G., 'The Signs of Faces: Leonardo on Physiognomic Science and the "Four Universal States of Man"', *Renaissance Studies*, XVI/2 (2002), pp. 143–62

Brown, David Alan, *Leonardo da Vinci: Origins of a Genius* (New Haven, CT, 1998)

Büdel, Oscar, 'Leonardo da Vinci: Medieval Inheritance and Creative Imagination', *Romanische Forschungen*, LXXIII/3–4 (1961), pp. 285–99

Bull, David, 'Two Portraits by Leonardo: "Ginevra de' Benci" and the "Lady with an Ermine"', *Artibus et Historiae*, XIII/25 (1992), pp. 67–83

Burke, Jill, 'Meaning and Crisis in the Early Sixteenth Century: Interpreting Leonardo's Lion', *Oxford Art Journal*, XXIX/1 (2006), pp. 79–91

Bush, Virginia L., 'Leonardo's Sforza Monument and Cinquecento Sculpture', *Arte Lombarda*, L (1978), pp. 47–68

Butterfield, Andrew, *The Sculptures of Andrea del Verrocchio* (New Haven, CT, 1997)

Chambers, David, et al., *Splendours of the Gonzaga*, exh. cat., Victoria & Albert Museum, London (London, 1981)

Covi, Dario A., 'Verrocchio and Venice, 1469', *The Art Bulletin*, LXV/2 (1983), pp. 253–73

Descendre, Romain, 'La biblioteca di Leonardo', in *Atlante della letteratura italiana*, ed. S. Luzzatto and G. Pedullà, vol. I (Turin, 2010), pp. 592–5

Dovev, Lea, '"On the Hand from Within": Palms, Selfhood and Generation in Leonardo's Anatomical Project', *Leonardo*, XLIII/1 (2010), pp. 63–9

Elam, Caroline, 'Lorenzo de' Medici's Sculpture Garden', *Mitteilungen des Kunsthistorischen Institutes in Florenz*, XXXVI/1–2 (1992), pp. 41–84

Farago, Claire J., 'Leonardo's Battle of Anghiari: A Study in the Exchange between Theory and Practice', *Art Bulletin*, LXXVI/2 (1994), pp. 301–30

—, *Leonardo da Vinci's 'Paragone': A Critical Interpretation with a New Edition of the Text in the Codex Urbinas* (Leiden, 1992)

Farago, Claire J., Janis Callen Bell, Carlo Vecce and Martin Kemp, eds, *The Fabrication of Leonardo da Vinci's 'Trattato della pittura', with a Scholarly Edition of the Italian 'Editio princeps' (1651) and an Annotated English Translation* (Leiden, 2018)

Fletcher, Jennifer, 'Bernardo Bembo and Leonardo's Portrait of Ginevra de' Benci', *Burlington Magazine*, LXXXI/1041 (1989), pp. 811–16

Formisano, Marco, *War in Words: Transformations of War from Antiquity to Clausewitz,* ed. M. Formisano and H. Böhme (Berlin and New York, 2011)

Frangenberg, Thomas, Rodney Palmer and Warburg Institute, eds, *The Lives of Leonardo* (London, 2013)

Frey, Karl, ed., *Il Codice Magliabechiano cl xvii 17: contenente notizie sopra l'arte degli antichi e quella de' Fiorentini da Cimabue a Michelangelo Buonarroti, scritte da Anonimo Fiorenti* (Berlin, 1892)

Garrard, Mary D., 'Who was Ginevra de' Benci? Leonardo's Portrait and its Sitter Recontextualized', *Artibus et Historiae*, XXVII/53 (2006), pp. 23–56

Gombrich, E. H., 'Grotesque Heads', in *The Heritage of Apelles* (London, 1976)

Greenstein, Jack M., 'Leonardo, Mona Lisa and "La Gioconda": Reviewing the Evidence', *Artibus et Historiae*, XXV/50 (2004), pp. 17–38

Gwynne, P. G., 'A New Contribution to the Biography of Leonardo da Vinci', *Burlington Magazine*, CLI/1277 (2009), p. 543

Herding, Klaus, and Nina Schleif, 'Freud's Leonardo: A Discussion of Recent Psychoanalytic Theories', *American Imago*, LVII/4 (2000), pp. 339–68

Kemp, Martin, *Leonardo da Vinci, the Marvellous Works of Nature and Man* (Oxford, 2006)

Kemp, Martin, and Giuseppe Pallanti, *Mona Lisa: The People and the Painting* (Oxford, 2017)

Kent, Francis William, *Lorenzo de' Medici and the Art of Magnificence* (Baltimore, MD, 2004)

Kwakkelstein, Michael W., 'Leonardo da Vinci's Grotesque Heads and the Breaking of the Physiognomic Mould', *Journal of the Warburg and Courtauld Institutes*, LIV (1991), pp. 127–36

—, Leonardo da Vinci's Drawings of Monstrous Heads: Creative Inventions or Observed Realities?', in *Ear, Nose and Throat in Culture*, ed. W. Pirsig and J. Willemut (Ostend, 2001)

Manca, Joseph, 'The Gothic Leonardo: Towards a Reassessment of the Renaissance', *Artibus et Historiae*, XVII/34 (1996), pp. 121–58

Marchesi, Monica, 'Further Investigations of Leonardo's "Leda and the Swan" at Rotterdam', *Master Drawings*, XLIII/3 (2005), pp. 349–55

Martin, John Jeffries, 'The Myth of Renaissance Individualism', in *A Companion to the Worlds of the Renaissance*, ed. Guido Ruggiero (Oxford, 2002), pp. 209–24

Meyer, Barbara Hochstetler, 'Leonardo's Battle of Anghiari: Proposals for Some Sources and a Reflection', *Art Bulletin*, LXVI/3 (1984), pp. 367–82

—, 'Leonardo's Hypothetical Painting of "Leda and the Swan"', *Mitteilungen des Kunsthistorischen Institutes in Florenz*, XXXIV/3 (1990), pp. 279–94

Meyer, Barbara Hochstetler, and Alice Wilson Glover, 'Botany and Art in Leonardo's "Leda and the Swan"', *Leonardo*, XXII/1 (1989), pp. 75–82

Musacchio, Jacqueline Marie, 'Weasels and Pregnancy in Renaissance Italy', *Renaissance Studies*, XV/2 (2001), pp. 172–87

Nagel, Alexander, 'Leonardo and Sfumato', *RES: Anthropology and Aesthetics*, XXIV (1993), pp. 7–20

Newton, H. Travers, and John R. Spencer, 'On the Location of Leonardo's Battle of Anghiari', *Art Bulletin*, LXIV/1 (1982), pp. 45–52

Pederson, Jill, 'Henrico Boscano's "Isola Beata": New Evidence for the Academia Leonardi Vinci in Renaissance Milan', *Renaissance Studies*, XXII/4 (2008), pp. 450–75

Pedretti, Carlo, Margherita Melani and Andrea Bernardoni, eds,
 Leonardo da Vinci and France (Amboise, 2013)
—, '"Non mi fuggir, donzella". Leonardo regista teatrale del Poliziano',
 Arte Lombarda, CXXVIII/1 (2000), pp. 7–16
Pizzorusso, Ann, 'Leonardo's Geology: The Authenticity of the "Virgin
 of the Rocks"', *Leonardo*, XXIX/3 (1996), pp. 197–200
Polzer, Joseph, 'Reflections on Leonardo's "Last Supper"', *Artibus et
 Historiae*, XXXII/63 (2011), pp. 9–37
Priest, Harold M., 'Marino, Leonardo, Francini, and the Revolving
 Stage', *Renaissance Quarterly*, XXXV/1 (1982), pp. 36–60
Rocke, Michael, *Forbidden Friendships: Homosexuality and Male Culture in
 Renaissance Florence* (New York, 1996)
Shell, Janice, and Grazioso Sironi, 'Cecilia Gallerani: Leonardo's
 Lady with an Ermine', *Artibus et Historiae*, XIII/25 (1992),
 pp. 47–66
—, 'Salaì and Leonardo's Legacy', *Burlington Magazine*,
 CXXXIII/1055 (1991), pp. 95–108
Simms, D. L., 'Archimedes' Weapons of War and Leonardo',
 British Journal for the History of Science, XXI/2 (1988), pp. 195–210
Solmi, Edmondo, and Arrigo Solmi, *Scritti Vinciani* (Florence, 1924)
Syson, Luke, and Larry Keith, *Leonardo da Vinci: Painter at the Court of
 Milan*, exh. cat., National Gallery, London (London, 2011)
Varriano, John L., *Tastes and Temptations: Food and Art in Renaissance Italy*
 (Berkeley, CA, 2019)
Vasari, Giorgio, *Le vite de' più eccellenti pittori scultori e architettori: nelle
 redazioni del 1550 e 1568*, ed. Rosanna Bettarini and Paola Barocchi
 (Florence, 1966)
—, *Lives of the Most Eminent Painters, Sculptors and Architects*, ed and trans.
 Gaston du C. de Vere (London 1912)
Visco, Giovanni, ed., *Descrizione della giostra seguita in Padova nel giugno 1466*
 (Padua, 1852)
Warnke, Martin, *The Court Artist: On the Ancestry of the Modern Artist*
 (Cambridge, 1993)
Wasserman, Jack, 'Rethinking Leonardo da Vinci's "Last Supper"',
 Artibus et Historiae, XXVIII/55 (2007), pp. 23–35
Zöllner, Frank, 'Ogni pittore dipinge sé': Leonardo da Vinci
 and "Automimesis"', in *Der Künstler über sich in seinem Werk.*

Internationales Symposium der Bibliotheca Hertziana, ed. Matthias Winner
(Weinheim, 1992), pp. 137–60

Zöllner, Frank, and Johannes Nathan, *Leonardo da Vinci, 1452–1519:
The Complete Paintings and Drawings* (Cologne, 2015)

ACKNOWLEDGEMENTS

My thanks to Francis Ames-Lewis, Pascal Brioist and Frank Zöllner for generously sharing their knowledge – all mistakes of course remain mine. I am much indebted to Clare Lappin and Agata Paluch, as well as to Michael Leaman, Alex Ciobanu, Martha Jay, Aimee Selby and Becca Wright of Reaktion Books for their support in the preparation of this book.

PHOTO ACKNOWLEDGEMENTS

The author and publishers wish to express their thanks to the below sources of illustrative material and/or permission to reproduce it. Some locations of artworks are also given below, in the interests of brevity:

Alte Pinakothek, Munich: 6; Biblioteca Ambrosiana, Milan: 20, 37, 38; Biblioteca Nacional de España, Madrid: 34; Biblioteca Reale, Turin: 36, 40; British Library, London: 29; British Museum, London: 22, 35, 54, 61; Castello Sforzesco, Milan: 23; Drumlanrig Castle, Dumfries and Galloway, Duke of Buccleuch Collection: 53; Fitzwilliam Museum, Cambridge: 26; Galleria Borghese, Rome: 48, 49; Gallerie degli Uffizi, Florence: 1, 3, 4, 7, 18; Gallerie dell'Accademia, Venice: 15, 42; Gemälde-galerie Alte Meister, Kassel: 45; The Hermitage Museum, St Petersburg: 5; Holkham Hall, Norfolk: 41; The J. Paul Getty Museum, Los Angeles (Open Access): 68; The Louvre Abu Dhabi: 57, 58; Musée Bonnat–Helleu, Bayonne: 9; Musée du Louvre, Paris: 2, 21, 25, 27, 39, 52, 55, 60, 63; Museum Boijmans Van Beuningen, Rotterdam: 46; Muzeum Narodowe/the Princes Czartoryski Museum, Kraków (inv. no. MNK-MKCz XII-209) – photo laboratory Stock National Museum, Kraków: 24; National Gallery of Art, London: 28, 51, 65, 66; National Gallery of Art, Washington, DC: 8, 10, 11, 64; The Norton Simon Museum, Pasadena, California: 59; Pinacoteca Vaticana, Musei Vaticani, Vatican City, Rome: 19; The Rijksmuseum, Amsterdam (Open Access): 47; Royal Library, Windsor Castle: 12, 13, 14, 16, 17, 33, 50, 56, 62, 67, 69, 70, 71; Santa Maria delle Grazie, Milan: 30, 31, 32; Szépmüvészeti Múzeum, Budapest: 43, 44.

INDEX

Illustration numbers are indicated by *italics*.